Figure It Out!
Human Proportions

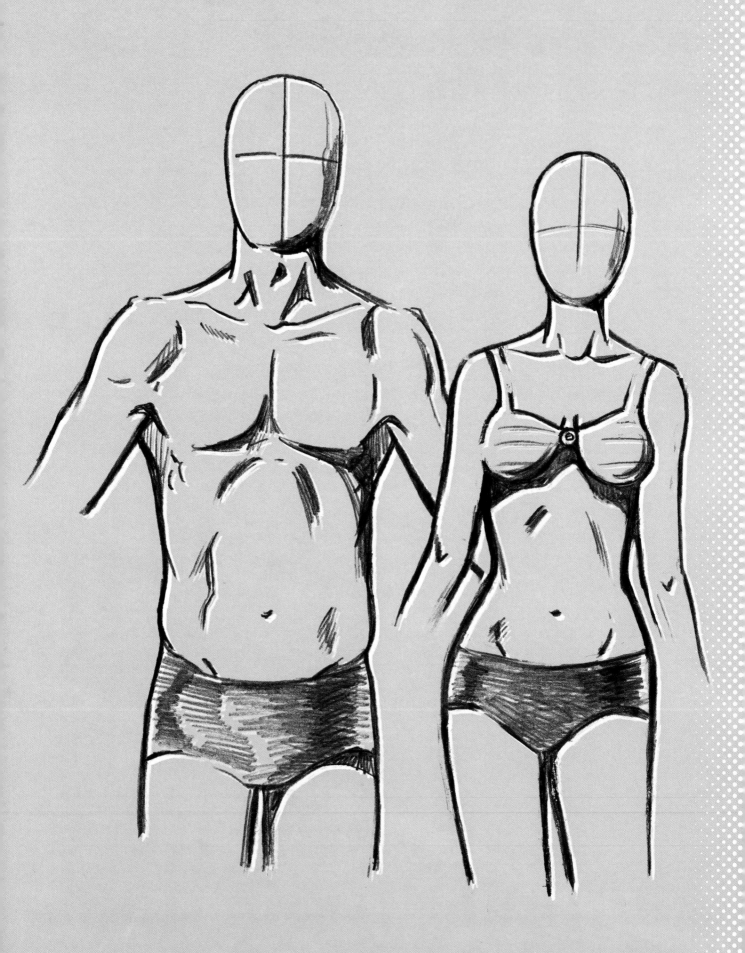

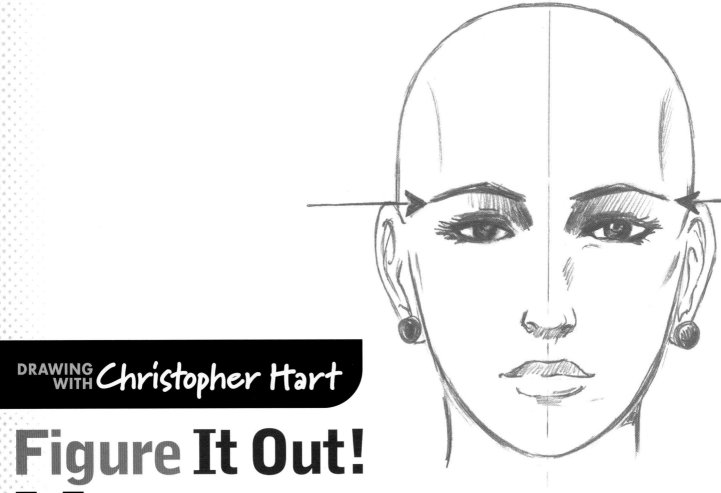

DRAWING WITH Christopher Hart

Figure It Out!
Human Proportions

DRAW THE HEAD AND FIGURE RIGHT EVERY TIME

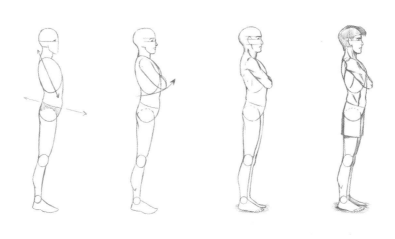

sixth&spring books

NEW YORK

DRAWING WITH *Christopher Hart*

An imprint of Sixth&Spring Books
161 Avenue of the Americas, New York, NY 10013
sixthandspringbooks.com

Editorial Director
JOY AQUILINO

Vice President
TRISHA MALCOLM

Developmental Editor
LISA SILVERMAN

Publisher
CARRIE KILMER

Design & Production
STUDIO2PTO, INC.

Production Manager
DAVID JOINNIDES

Editorial Assistant
JOHANNA LEVY

President
ART JOINNIDES

Copyeditor
ALISA GARRISON

Chairman
JAY STEIN

Proofreader
ANDREA CURLEY

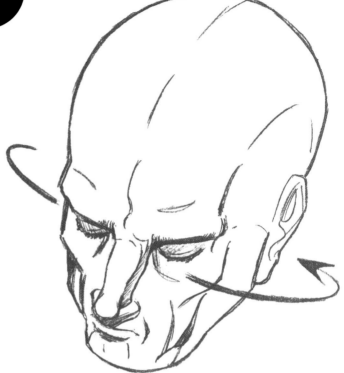

Library of Congress Cataloging-in-Publication Data
Hart, Christopher, 1957–
Figure it out! human proportions : draw the head and figure right every time / by Chris Hart. — First Edition.
 pages cm
Summary: "From bestselling art instruction author Chris Hart, a fresh new approach to teaching the fundamentals of human proportion to artists who are learning how to accurately draw the human head and figure that also serves as a refresher or quick reference for more experienced artists"— Provided by publisher.
Includes bibliographical references and index.

ISBN-13: 978-1-936096-73-2 (pbk.)
ISBN-10: 1-936096-73-0
1. Figure drawing—Technique. 2. Head in art. I. Title.
NC765.H188 2014
743.4'9—dc23
 2013034431

Manufactured in China

1 3 5 7 9 10 8 6 4 2

First Edition

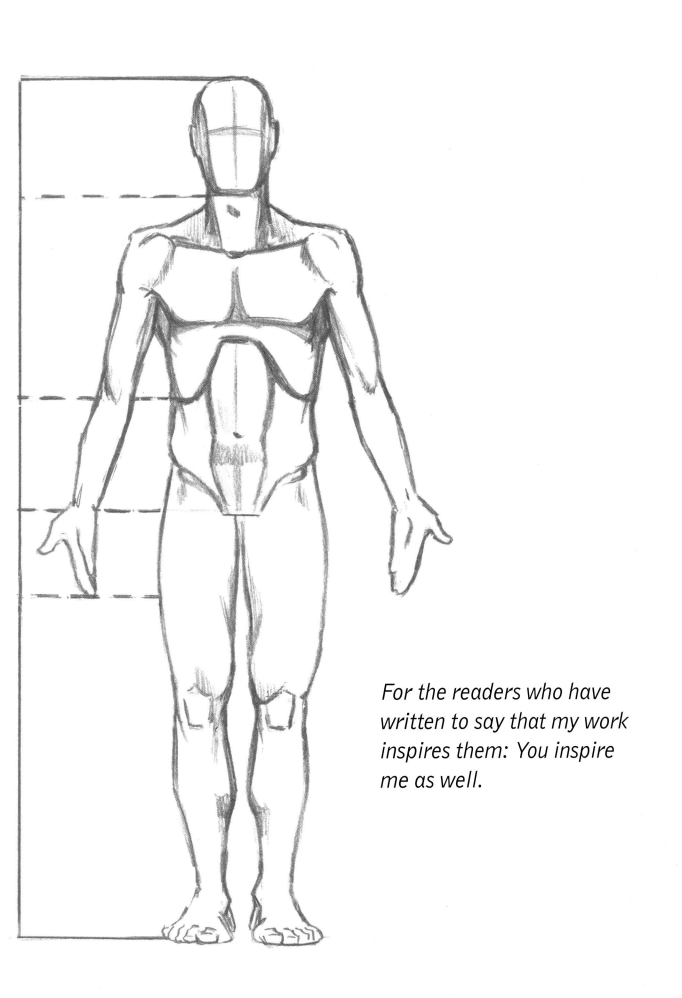

For the readers who have written to say that my work inspires them: You inspire me as well.

Contents

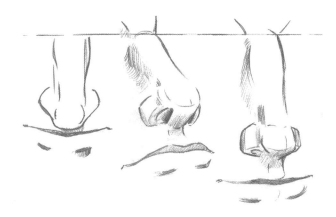

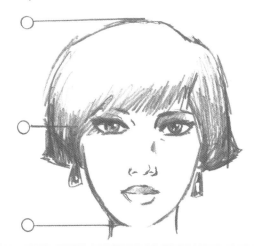

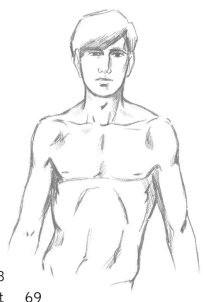

Step-by-Step Tutorials: The Figure 114

Preface

Proportions are simple measurements that allow you to self-check your work and to make the necessary adjustments. Proportions exist for almost every part of the body, and are surprisingly consistent from person to person. Until now, you probably relied on intuition to draw the facial features and the body. Sometimes intuition worked, but sometimes it didn't. And sometimes, it may have "looked right" when, in fact, the proportions were off.

Figure It Out! Human Proportions will give you the tools to draw the correct figure every time. No more guesswork. Here — plainly written and clearly illustrated — is *all* the essential information for artists at *all* levels, demonstrating the proportional relationships of the head and body from *all* angles: front, side, and back.

Why waste time worrying if you drew an arm too long or too short, or if the ears are too high or too low? It's better to know than to guess. Knowing the correct proportions allows you to feel confident and can greatly accelerate your learning curve in figure drawing.

This essential guidebook to human proportions takes a fresh approach. The study of anatomy is, of course, important — and recommended. But it's also a subject

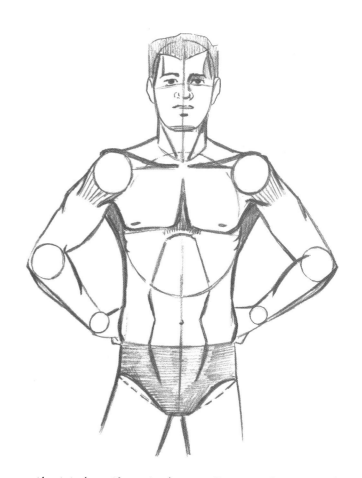

that takes time to learn. Proportions, on the other hand, can be applied immediately. Some artists use photographs for reference. But that only works if you're drawing the same pose as in the photo. If you alter the pose, the reference material may no longer apply.

Proportions have typically been taught with complex diagrams and measurements of questionable usefulness. But if you're looking for a practical guide, then this is the book to own. It prioritizes information to focus solely on what's relevant to drawing the human figure. And it's organized for easy reference, beginning with the head and working its way down the body.

This guide will give you many "aha!" moments, in which the correct proportions make sense to you at a gut level. When that happens, you'll never forget what you've learned, because it becomes a part of you.

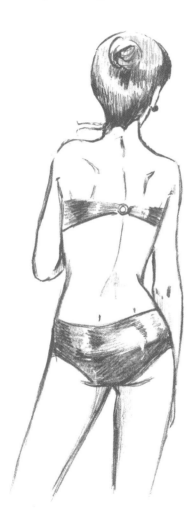

A professional illustrator I knew was giving advice to young artists. After demonstrating some established rules to be followed, he closed with this final thought: "Just remember, if

it looks right, it is right." And so it is with proportions—within reason. Not every drawing requires perfect accuracy. My goal has been to provide some practical answers for the aspiring or more experienced artist. If your drawing looks off, and you believe you should make an adjustment, now you know where to turn for answers.

Thank you for the privilege of allowing me to be, in some small way, a part of your creative journey.

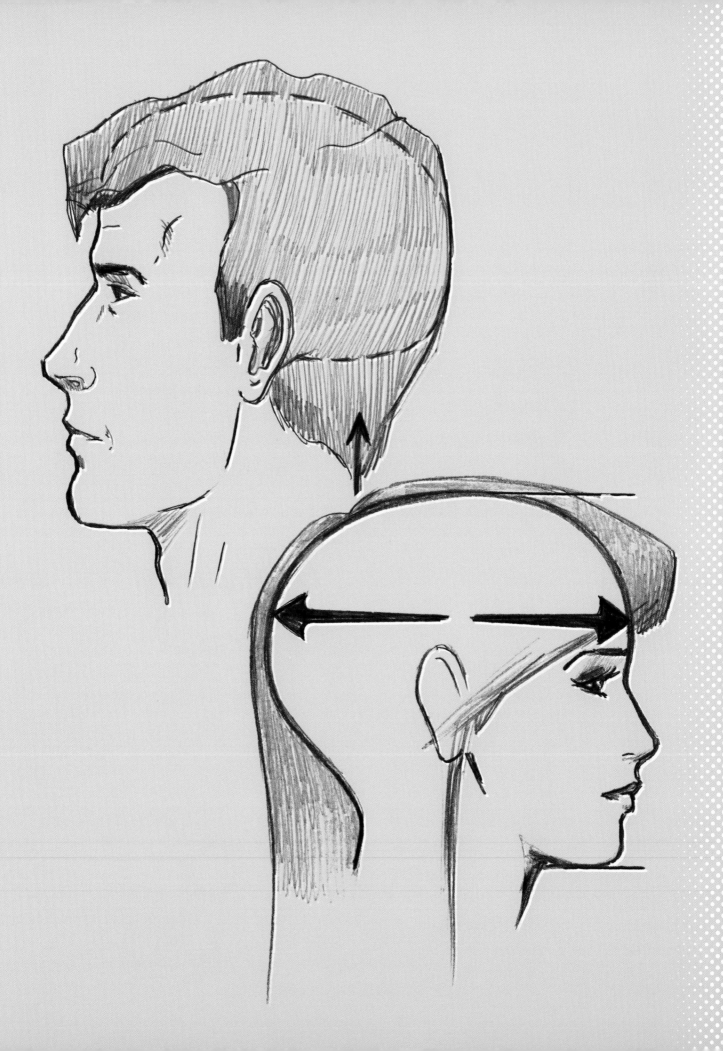

Proportions of the Head

Most of us have struggled at some point to draw the head, never considering that perhaps we were using too much effort rather than too little. In this chapter, you will see that the key is to start out with the correct shape and the correct placement of the facial features. With this approach, everything else falls into place astonishingly quickly, with relative ease. Some of these proportions may challenge your long-held assumptions. Not all proportions are intuitive; as we'll discover, simply depending on your intuition for accuracy isn't a reliable approach.

The Outline of the Head

We're all aware that the jaw tapers as it travels from the cheekbones to the chin. It's plain to see. But there's also some additional tapering going on elsewhere on the head. The widest part of the head is the sides of the skull (*temporal fossa*), not the cheekbones. The head tapers from the sides of the skull to the cheekbones, and then continues to taper from the cheekbones to the jaw and to the chin.

KEY POINT

The sides of the skull are the widest points of the head.

Guidelines and the "T"

Guidelines help us do two very important things: They serve to keep the features symmetrical on both sides of the face (on either side of the center line), and they keep everything looking level across the face (following the eye line). We'll be using these simple guidelines throughout the book. But they're not just for beginners. Very experienced artists and pros also draw using the center line and eye line as guides.

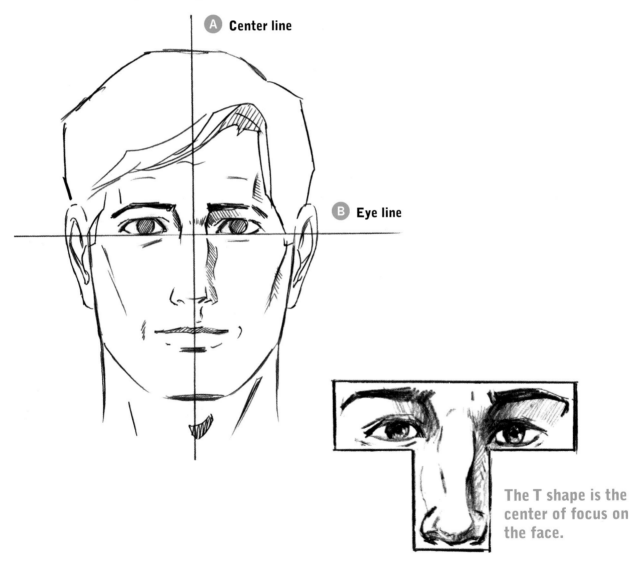

A Center line

B Eye line

The T shape is the center of focus on the face.

The "T" in the Middle of the Face

The features that make up the focal point of the face form a T shape in the center of the face. The eye is naturally drawn to this cluster of features. It is a constellation of the eyebrows, eyes, bridge of the nose, and nose.

The Planes of the Head

The head is often shown as an egg shape or a box shape in drawing books. Either is a good starting point. But you need something more accurate if you want to draw the head correctly.

First, let's recognize that what we think of as the face is only the front "faceplate." The side planes travel on an angle inward toward the nose, which is on the front faceplate.

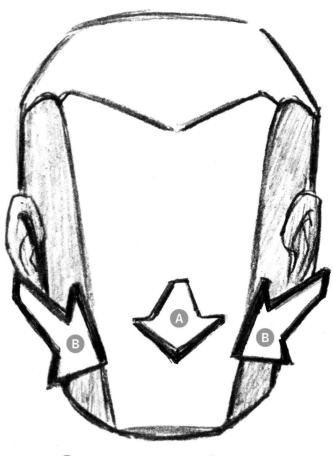

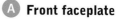 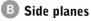

A Front faceplate **B** Side planes

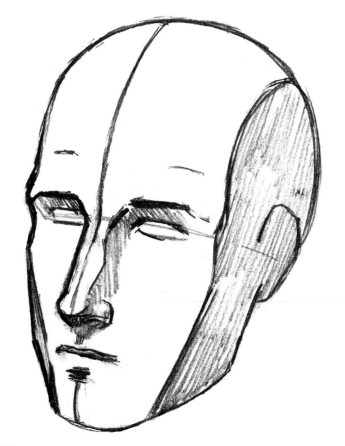

The side planes give the face a tapered appearance. (Most often, the far side of the face isn't seen in the ¾ view; however, this head is angled toward us enough to make it slightly visible, which helps to demonstrate this principle.)

Height and Width

Although it may seem counterintuitive, the head is as wide from side to side (in profile) as it is long (from the top of the head to the bottom of the chin).

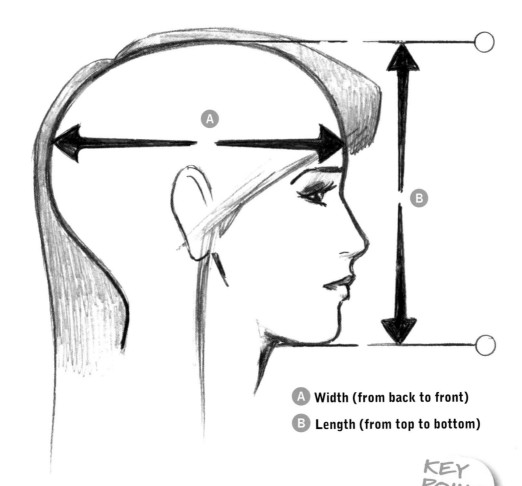

Ⓐ Width (from back to front)

Ⓑ Length (from top to bottom)

KEY POINT

In profile, the height and width of the head are equal.

The Side View and Asymmetry

The relatively flat surface of the forehead is counterbalanced by the rounded back of the head. But the positions are slightly different, with the back of the skull ending at a lower point (the eardrum) than the forehead (the bridge of the nose).

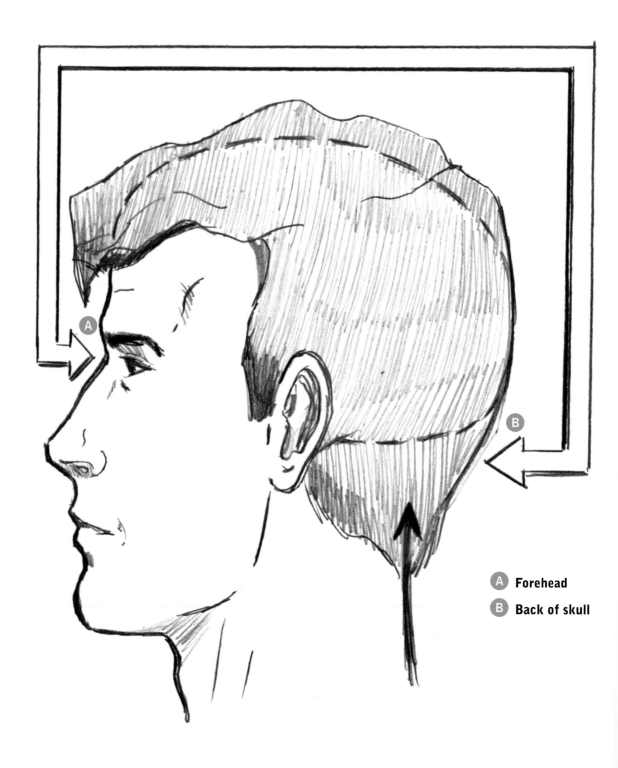

A Forehead

B Back of skull

What We See from the Side

In the front view, the back of the head is obscured from view. In the profile, we see the back of the head at its fullest. When drawing the ¾ view, some artists don't show enough of the back of the head. But as you can see from this comparison, a significant portion of the back of the head remains visible even in the ¾ view.

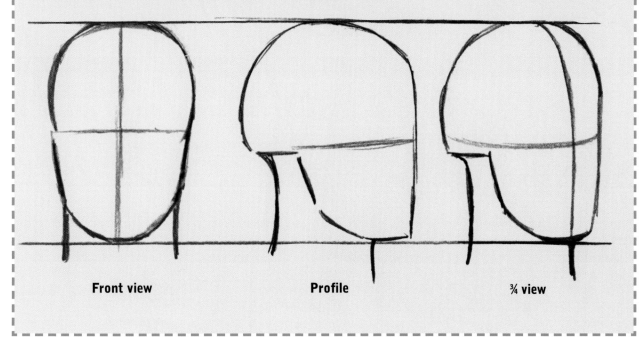

Front view **Profile** **¾ view**

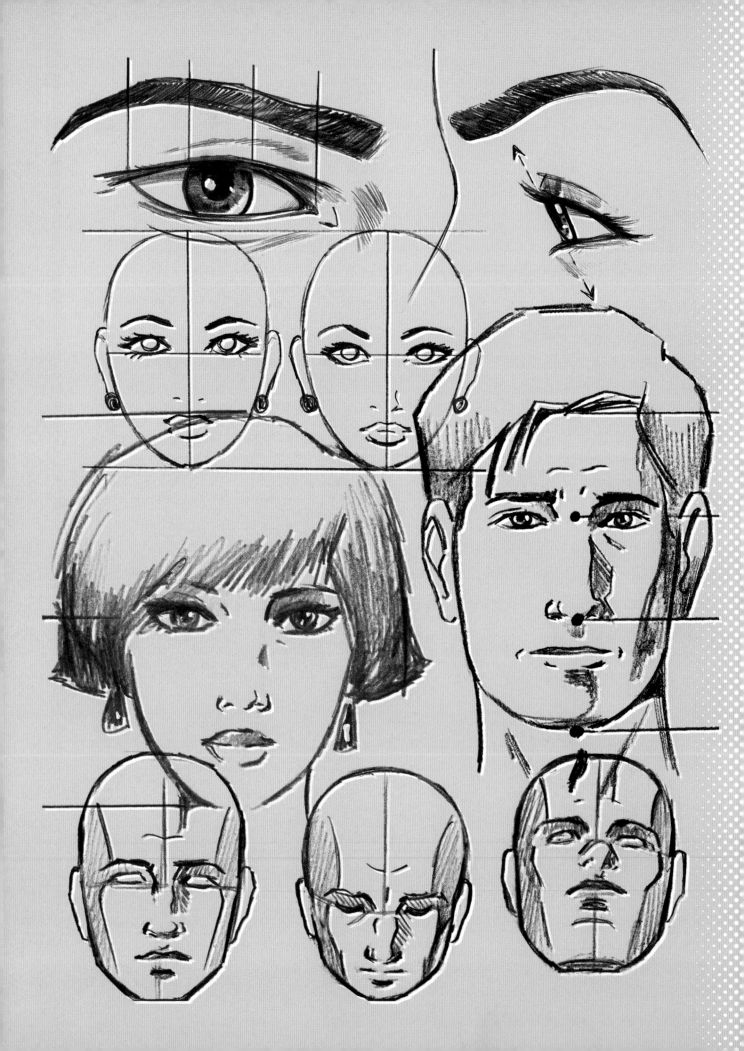

Features of the Face

When drawing the face, many artists focus on getting the individual features just right, though many errors result when the distances between and relationships among the features are off. Having the correct knowledge of the proportions is a game changer—for both the look of a drawing and the time it takes to create it. Let's get you that advantage right now!

Simplifying the Eye and the Eyebrow

The proportions of the eye are simple and straightforward; it divides into 3 equal parts:

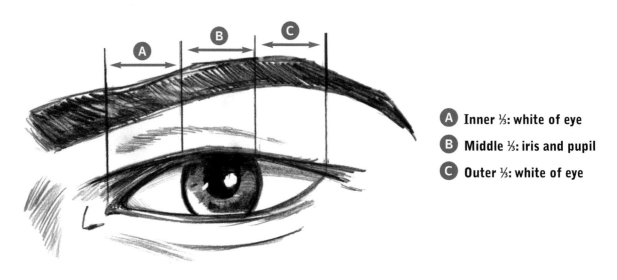

A Inner ⅓: white of eye

B Middle ⅓: iris and pupil

C Outer ⅓: white of eye

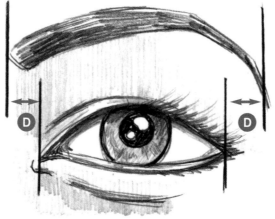

D The eyebrow extends past the eye on both ends.

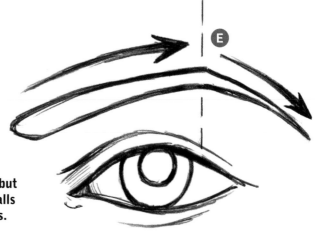

E The eyebrow's arch can vary, but generally, the highest point falls over the outer edge of the iris.

The Eyebrow and the Temporal Ridge

The average person's eyebrow takes a sharp downward turn at the outer edge of the forehead. The spot where this occurs is a part of the skull called the *temporal ridge*. It marks a shift in angle from the frontal plane of the head (the face) to the lateral plane of the head. Put simply, the eyebrow is literally wrapped around two planes of the head, which is why you notice that sudden shift in its angle.

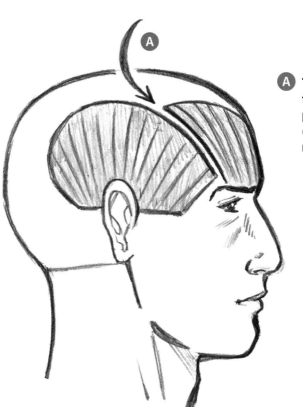

A The temporal ridge marks the point where the front plane of the face ends and the lateral plane of the head begins. The cranial muscles on the sides of the head are separated by a ridge of bone—that's the temporal ridge.

B The temporal ridge is visible in many poses and at many angles.

Eye Length and the Width of the Head

A common fact about proportions, which you may have heard, is that the face is 5 eye lengths wide. This measurement helps in determining not only the length of the eyes but also the width of the face. Although the average face is 5 eyes wide, some faces are slightly narrower than others. It's not uncommon for a person's head to be just under 5 eyes wide.

KEY POINT

The head is 5 eye lengths wide.

The Distance Between the Eyes

Knowing that the eyes are 1 eye length apart makes it easy to check that the eyes don't appear to be too close together or too far apart. There's one additional consideration in drawing the eyes, which is equally important, to prevent a lopsided appearance: The space between the eye and the edge of the face should be the same on both sides.

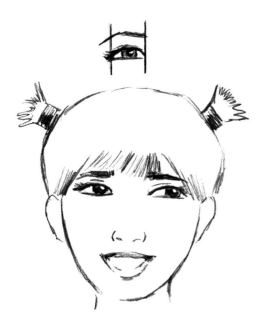

Here's how to double-check your proportions without actually having to draw a third eye between the other two. Above the head, draw two vertical lines, one aligning with the left tear duct, the other aligning with the right tear duct. Measure the distance between the two lines. It should be equal to the width of each eye. If it isn't, don't worry. Make an adjustment, then remeasure. Repeat until the two measurements are equal.

KEY POINT

The eyes are separated by a single eye length.

The finished drawing with the correct eye placement.

Where the Eyes Go

The *center line* and the *eye line* are essential to mapping out where to draw the eyes. The center line is the vertical guideline, and it maintains symmetry on both sides of the face. For example, if you draw the left eye ½ inch from the center line, then you should also draw the right eye ½ inch from the center line. In a front view of the face, the lips would be bisected directly down the middle by the center line, as would the nose, and so forth.

The eye line is the horizontal guideline. Its purpose is to keep both eyes level with each other. This line bisects the head horizontally. The center line and the eye line intersect at the indentation from which the bridge of the nose originates.

In this basic head construction with guidelines, note that the eye line (the horizontal guideline) falls in the middle of the head, not higher, which is a common misconception.

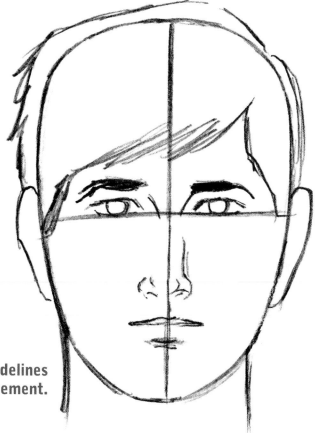

Hang the features on the guidelines to ensure proper placement.

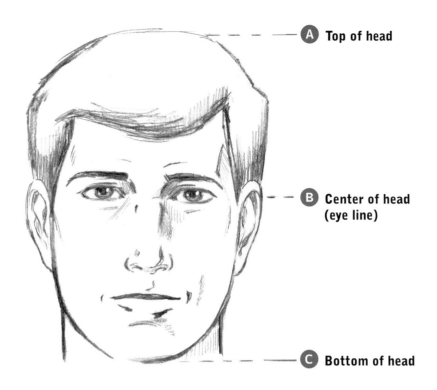

A — Top of head

B — Center of head (eye line)

C — Bottom of head

KEY POINT

The eyes are drawn at the halfway point on the head, as measured from top to bottom.

The Cornerstone of Correct Eye Placement

The eyes are the cornerstone of facial construction. Many, if not most, people believe the eyes are located toward the top of the head. Reality is different. They're located directly in the middle, when measuring the head from top to bottom.

Why, then, do we share the erroneous view that the eyes fall near the top of the head? Throughout the course of a typical day, we see numerous faces. In our mind's eye, we frame them from the hairline to the bottom of the chin; however, the hairline is not actually the top of the head but the top of the *forehead*. The skull continues to ascend above the hairline, adding more length. You should measure the length of the head from its *actual* top, not from the *perceived* top. When the true length of the head is taken into account, the eyes fall at the halfway mark every time.

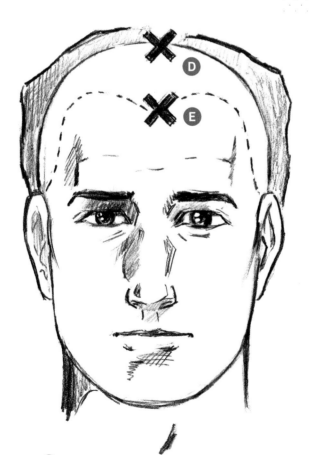

D — Actual top of head

E — Hairline falls at top of forehead

25

Eye Placement in Action

Here are two examples of eyes drawn in correct proportion to the head: at the midpoint as measured from top to bottom. It may still seem like the eyes are higher; after all, a lifetime of perceiving something in a certain way doesn't change overnight. But by becoming aware of the correct measurements, you can change your perception.

A Midpoint

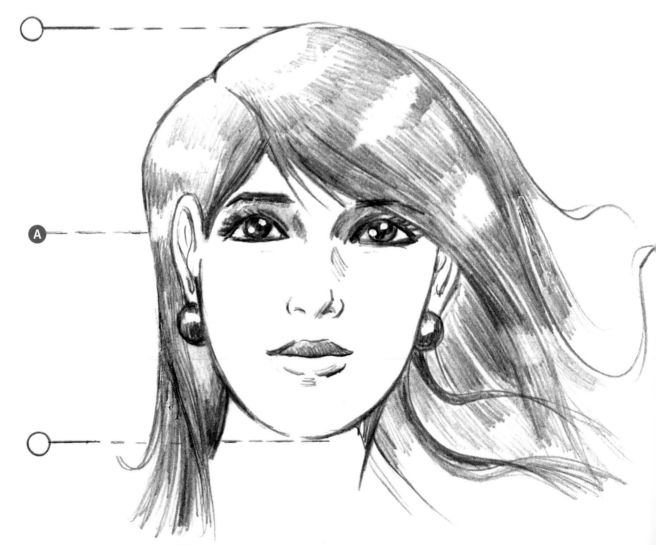

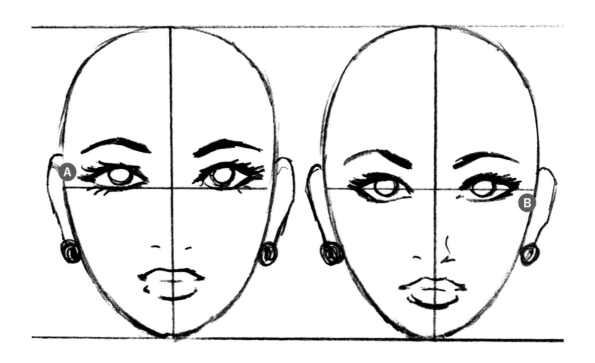

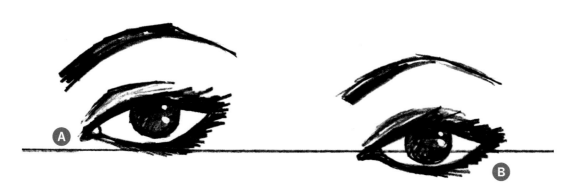

A Eyes rest on top of eye line

B Eyes are bisected by eye line

Eye Level Variations

Traditionally, the eyes are drawn with the eye line running directly through them horizontally. But this adds clutter to the interior of the eyes, so many artists prefer to make a small adjustment, drawing the eyes *on top of the eye line*. This small adjustment will not affect the basic accuracy of the proportion. After all, we're artists, not engineers.

Age and the Eye Line

Age affects proportions. That's why medieval paintings of children look so strange. Artists of that period painted children with adult proportions and simply shrank the head and body sizes. When drawing children, adjust not only the size of the head and body but the proportions as well.

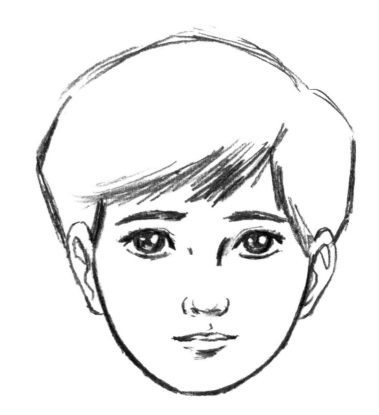

Children

Children's eyes fall slightly below the middle of the head; note the lowered eye line. Other differences in youthful proportions are:

Lower hairline
Slightly bigger eyes in relation to head
Shorter, smaller nose
Shorter lips, with a slight curl of upper lip
Larger forehead
Smaller jaw
Slightly lower ears
Small chin
Smooth angle of the jaw

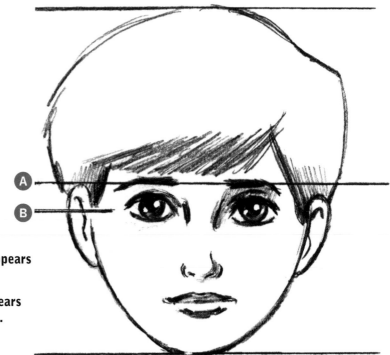

A The average adult eye line appears at the center of the head.

B The eye line for children appears below the center of the head.

KEY POINT

The younger a person is, the lower the eye line; the older a person is, the higher the eye line.

Older Adults

On older adults, the eye line falls *above* the midpoint of the head. This shift in proportions affects the forehead, which must then be reduced in size. Other shifts are:

Smaller eyes
Fuller eyebrows
Higher hairline
Larger nose
Longer ears
Thinner lips
Longer chin
Pronounced angle of the jaw

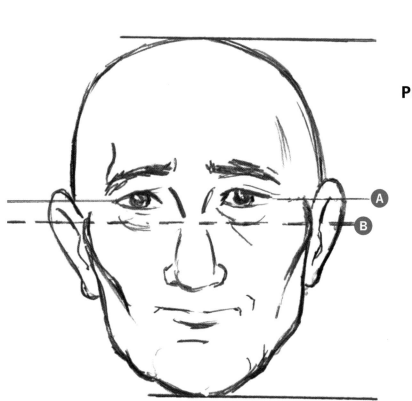

On older adults, bony areas of the skull are more evident (the cheekbones and jawline), and the lateral areas of the face may also be slightly sunken.

Ⓐ Eye line for older adults

Ⓑ Correct eye line for average adults

The Eye in Profile

In profile, the center line is sketched lightly as an invisible guideline that runs down the front of the face. This serves as a consistent base from which the features and contours protrude.

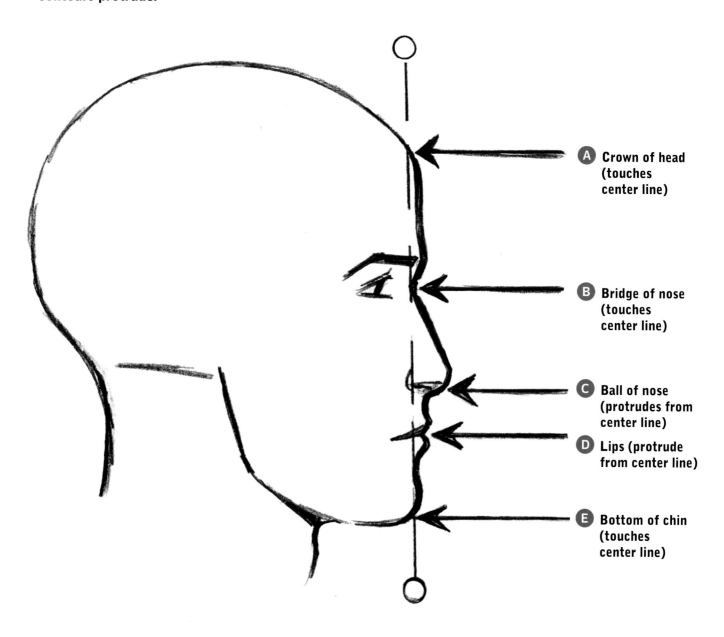

A Crown of head (touches center line)

B Bridge of nose (touches center line)

C Ball of nose (protrudes from center line)

D Lips (protrude from center line)

E Bottom of chin (touches center line)

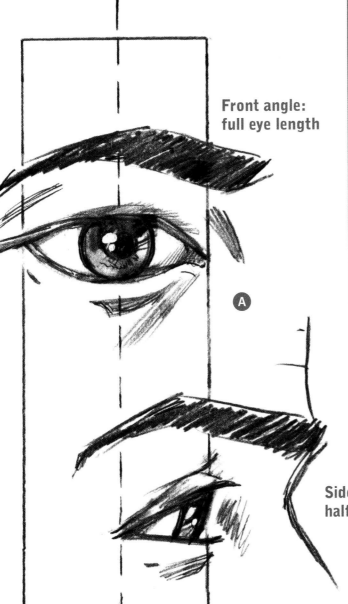

Front angle:
full eye length

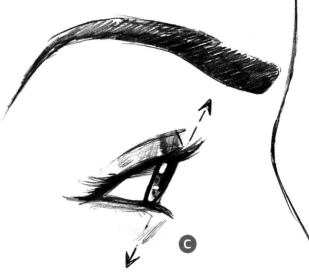

Front View vs. Side View

Most of us are aware that the shape of the eye is different in a profile than it is in a side view. In the Middle Ages, artists weren't always aware of this, and they often drew eyes in the front view all the time. This made their drawings look completely wrong. But it's not just the shape of the eye that differs in the side view; it's the size of the eye—its width.

Side view:
half eye length

A In the front view, although the eyelids slope, the basic thrust of the lines is horizontal.

B In profile, the upper eyelid is drawn on a diagonal; the bottom can also be drawn on a diagonal but is sometimes flatter.

KEY POINT

The eye in profile is roughly half the width of the eye in the front view.

C The eyeball appears to tilt slightly forward in the side view.

Aligning the Eye

Acommon tendency among beginners is to draw the eye too close to the edge of the front of the face in a profile. The correct distance from the edge of the face—one eye length—is a small one, but unless you know it, it's easy to overshoot or undershoot the mark.

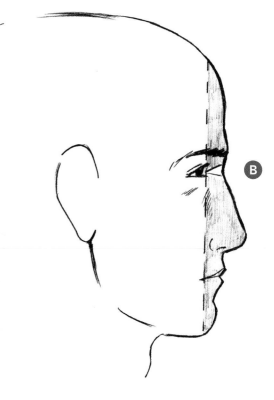

A How to find the right proportion (one eye length) outside of the drawing.

B How to find the right proportion inside of the drawing (an eye length between the eye and the bridge of the nose).

KEY POINT

In profile, the eye is 1 eye length back from the front edge of the face.

Eye Placement Variations

As with the front view, the correct proportion is to center the eye at the bridge of the nose, but there is a subtle variation you can choose.

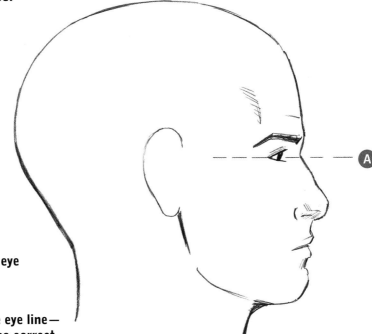

A The eye is centered on the eye line—correct.

B The eye rests on top of the eye line—a stylistic choice that is also correct.

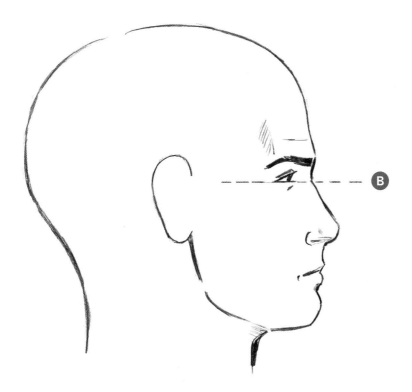

The Nose

Because of its prominence on the face, a nose that's drawn too long or too short will draw attention to itself. If it's short, the upper lip will appear too long. Alternatively, a nose that's too long emphasizes the length of the face. But a nose drawn with the correct proportions allows the eyes to dominate the face—as they should.

Nose Length

To determine the length of the nose, we'll need two measuring points: the hairline and the bridge of the nose. But what if your character has a receding hairline or is bald? No problem; simply approximate where the hairline would be if the subject had a full head of hair. This is usually at the crown of the head, where there's a subtle shift in angle from the dome of the head to the forehead.

Using the crown as the starting point, measure to the bridge of the nose. The approximate distance between them equals the length of the average nose. For example, let's say that on your drawing it's 3 inches from the crown to the bridge of the nose. We would then make a mark 3 inches down from the bridge of the nose to arrive at the length of the nose itself.

KEY POINT

The length of the nose is equal to the distance between the crown and the bridge of the nose.

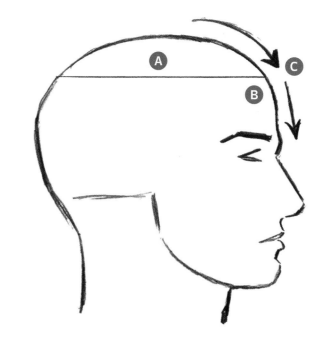

Ⓐ **Dome** Ⓑ **Forehead** Ⓒ **Crown (note shift in angle)**

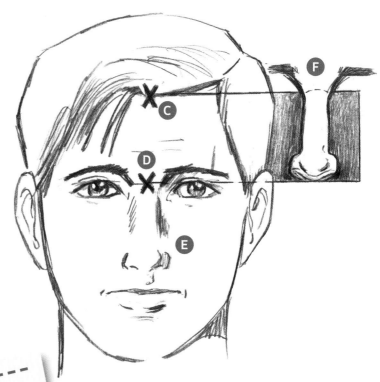

Ⓒ **Crown**

Ⓓ **Bridge of nose**

Ⓔ **Length of nose**

Ⓕ **Use the distance from the crown to the bridge of the nose as the length of the nose, starting at the bridge of the nose and traveling down toward the mouth.**

Nose Length in Profile

The concept for determining the proportions of the nose may be easier to visualize in the side view. Just remember that the distance from the crown to the bridge of the nose equals the distance from the bridge of the nose to the bottom of the nose. You're repeating the distance between the crown of the head and the bridge of the nose to determine the correct nose length.

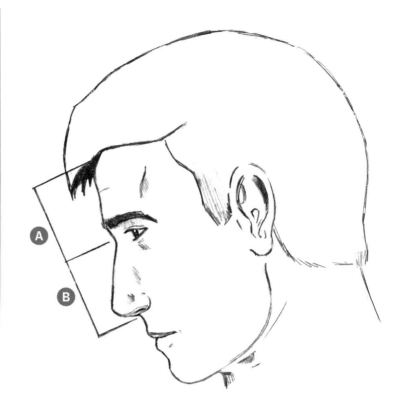

Ⓐ The distance from the crown to the bridge of the nose . . .

Ⓑ . . . equals the distance from the bridge of the nose to the bottom of the nose.

You don't need to get it right on the first try. Check your proportions and revise until you're happy with the results.

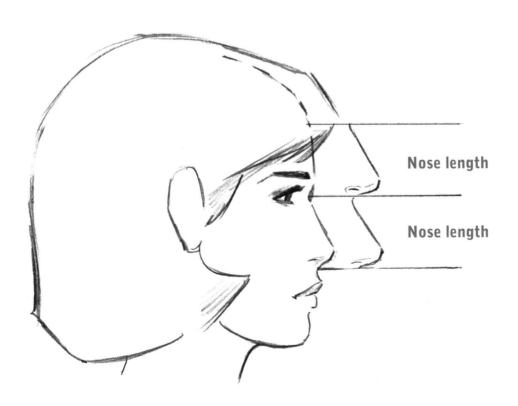

Nose length

Nose length

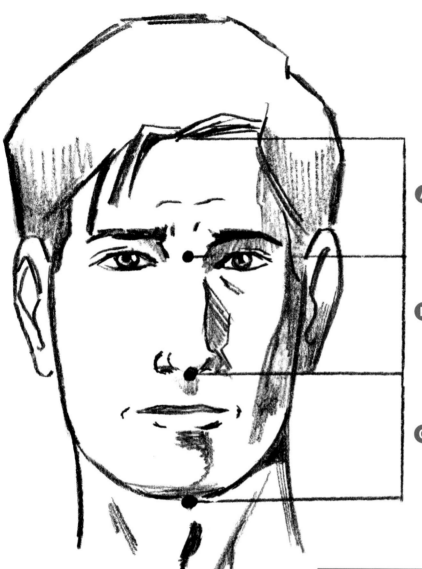

A Top ⅓ (crown to bridge of nose)

B Middle ⅓ (bridge of nose to bottom of nose)

C Bottom ⅓ (bottom of nose to bottom of chin)

Using the Nose to Size the Head

Here we continue to use the nose as a measuring device by simply dividing the head, lengthwise, into thirds. This will give you the correct length of the bottom third of the face (the mouth area).

Nose Width

Most tutorials on perspective tell you what the width of the nose should be. What they don't tell you is that the width of the nose varies greatly. The rule should be understood as a general guideline, which is this: The nostrils are about as wide as the distance between the tear ducts.

Depending on the individual subject, artists also draw the width of the nostrils slightly narrower than the distance between the two tear ducts. Take a look at these variations.

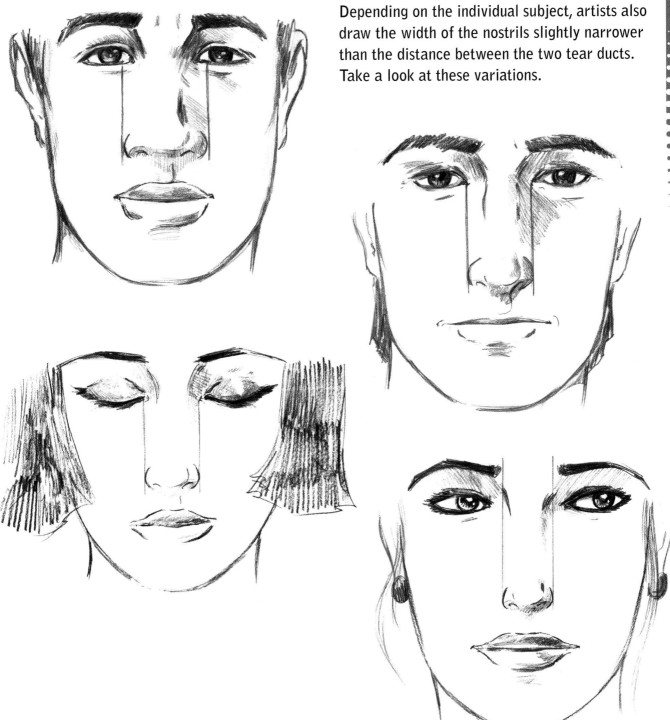

The Mouth

If the mouth falls too low on the face, the upper lip will appear uncomfortably long, which looks odd. A low mouth leaves little room for the chin, which in turn can make it look weak.

Fortunately, there's a simple method for determining correct mouth placement: Draw the lower lip halfway between the bottom of the nose and the bottom of the chin.

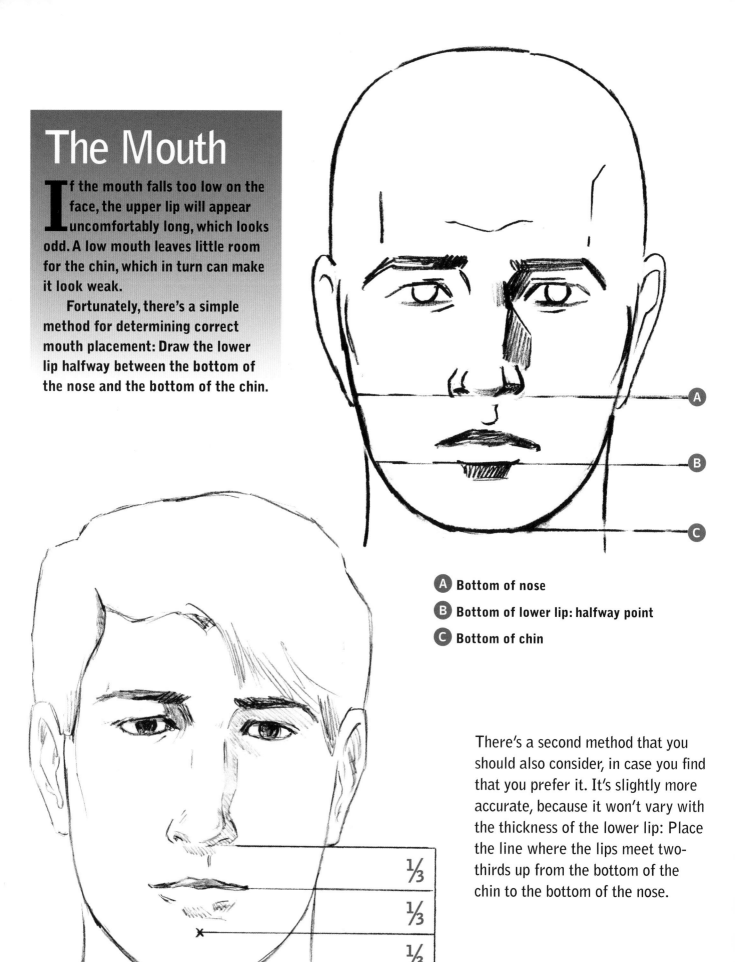

A Bottom of nose

B Bottom of lower lip: halfway point

C Bottom of chin

There's a second method that you should also consider, in case you find that you prefer it. It's slightly more accurate, because it won't vary with the thickness of the lower lip: Place the line where the lips meet two-thirds up from the bottom of the chin to the bottom of the nose.

$\frac{1}{3}$

$\frac{1}{3}$

$\frac{1}{3}$

Mouth Width

The standard measurement for the width of the mouth is the distance between the pupils. But once again, this general guideline includes a range of widths. Some artists, such as myself, prefer to draw a smaller mouth. These minor variations are simply aesthetic choices.

This measurement does more than give you the correct mouth width. It also centers the mouth, ensuring symmetry: From the center line, the lips should extend equal distances to both the left and right pupils.

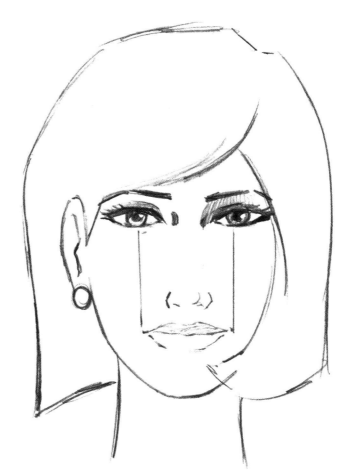

Width of the pupils

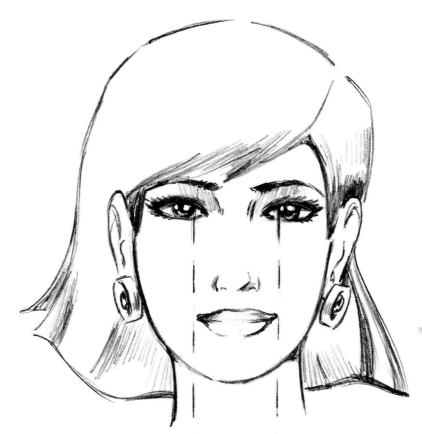

Width of the irises

KEY POINT

The corners of the mouth align with the pupils or the inner edge of the irises, depending on the individual.

The Depth of the Mouth in Profile

In profile, the relaxed lips are surprisingly short in depth. Because the lips are elastic, their depth varies with their expression. But the relaxed lips give us the baseline proportion, which is that, in profile, the corner of the mouth aligns with the front edge of the eye.

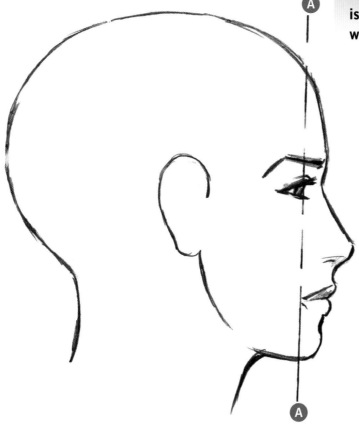

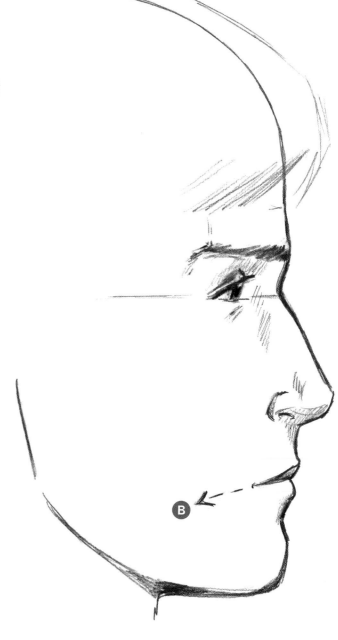

Ⓐ The corner of the lips and the front plane of the eye align vertically.

Ⓑ In profile, the relaxed lips slope slightly downward toward the corner of the mouth.

The Angle of the Jaw

This facial landmark is lesser known but important for the lower half of the face. Most artists don't make a conscious decision about where to place the spot at which the jawline angles inward toward the chin. This point is called the *angle of the jaw*, and beginners often start it just below the ears, which is wrong. This makes the face appear unrealistically narrow. The correct location is even with, or just below, the mouth.

The skull shows us that the angle of the jaw does not begin at the bottom of the ears. The angle of the jaw actually begins where the top and bottom teeth meet, or slightly below that line. The jawbone travels downward from the ears (with only a slight slant inward) until it reaches the level of the mouth, where it turns sharply inward.

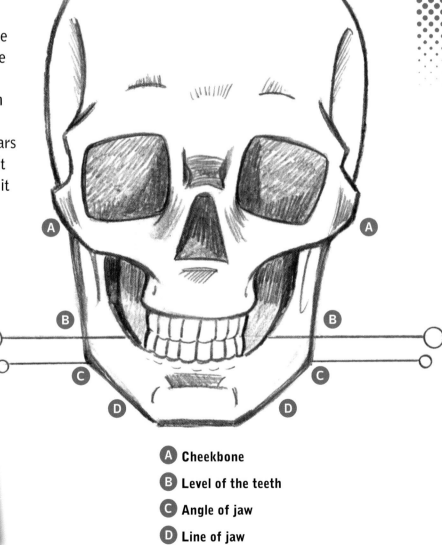

KEY POINT

The angle of the jaw occurs at, or just below, the level of the mouth.

A Cheekbone
B Level of the teeth
C Angle of jaw
D Line of jaw

41

Where the Jawline Starts

The jawline on the average person is even with the mouth, or slightly below it. The lower it is, the wider the face will appear.

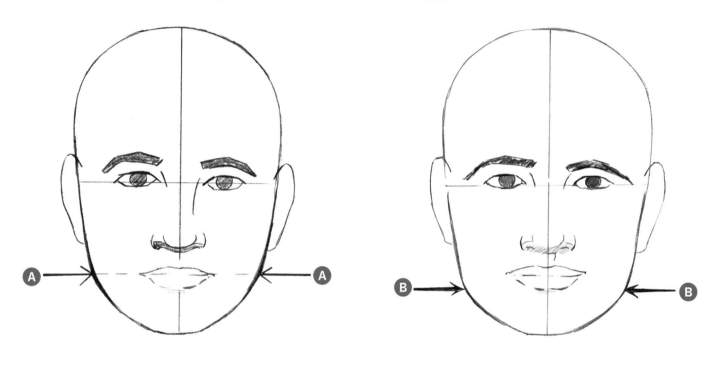

A Jawline even with mouth

B Jawline slightly below mouth

Finished pencil sketch, with a guideline running from the left angle of the jaw to the right one

The Ears

The eyebrows and the tops of the ears should be at the same level. Similarly, the bottoms of the ears and the bottom of the nose are at the same level. This is an essential landmark and measurement for the face, as it keeps several important features in the correct position, *in relation to one another.*

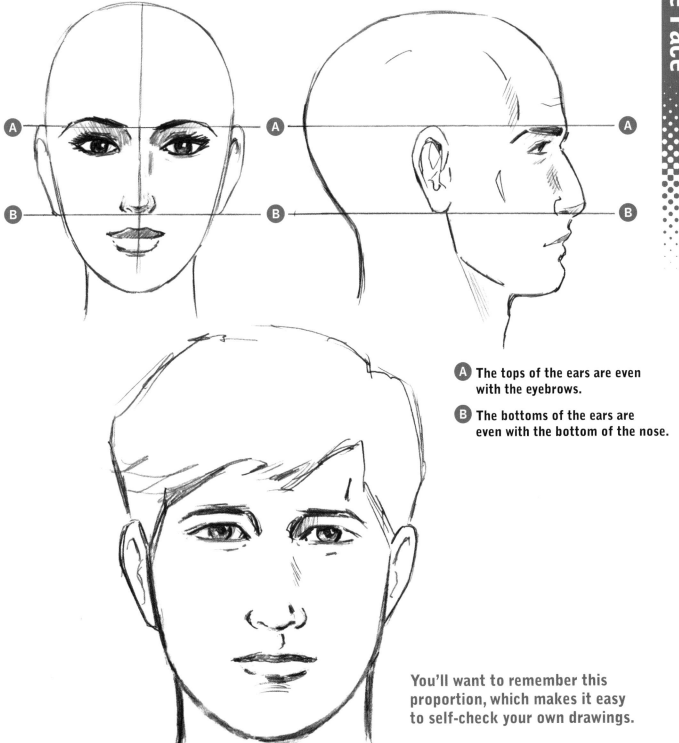

A The tops of the ears are even with the eyebrows.

B The bottoms of the ears are even with the bottom of the nose.

You'll want to remember this proportion, which makes it easy to self-check your own drawings.

The Ear, Side View

We've established the placement of the ears in relation to the facial features in the front view. But what about the side view? How close to the front of the face is the eardrum drawn?

Many people make the common mistake of positioning the ear too far back on the head. This has the unwanted effect of making the skull appear shallow or flat. The eardrum is centered on the head, but the outline of the ear appears behind it, slightly off-center. Remember that we measure the front of the face from the *faceplate*, not from the tip of the nose.

(A) The ear canal is located at the center of the head, as measured from front to back.

What if you forget and draw the ear cartilage dead center instead of back a notch? Not to worry; a minor detail like that is never a fatal flaw, unless you're creating medical illustrations.

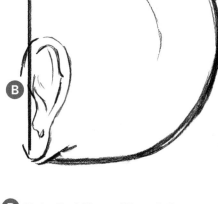

(B) Note that the outline of the ear is slightly back from the midpoint of the head.

Quick Check: Simplified Proportions of the Head and Face

Not every proportion has to be embedded in a drawing from the outset. In fact, few artists would go to that extreme. Rather, they complete their initial drawing before self-checking and refining the proportions. The following are diagrams of basic proportions for drawing the head and face, which may be all you need to complete an initial rough.

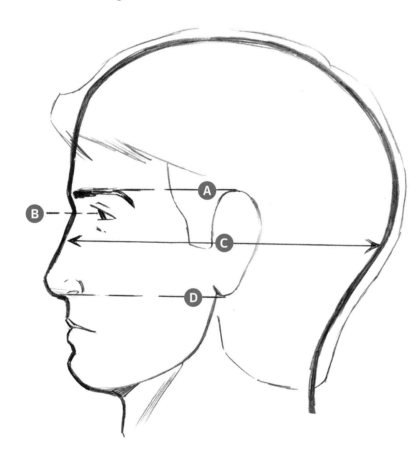

A Eyebrow level with top of ear

B Eye even with bridge of nose

C Ear canal in middle of head (in profile)

D Bottom of nose level with bottom of ear

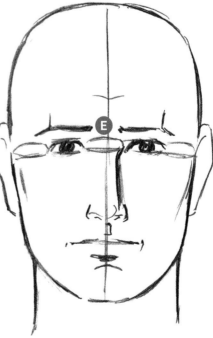

E Self-check to be sure. The head is 5 eye lengths wide, with 1 eye length between the eyes.

The Effects of Head Tilts on Proportions

Anyone who has tried to draw an upward-tilting or downward-tilting head knows how maddening it can be. The results will not appear correct unless the positions of the features also are altered to reflect the change in perspective. Mistakes can often be attributed to an artist's instinctive effort to maintain the proportions of the head as if there were no tilt.

KEY POINT

A change in the tilt of the head produces a change in the proportions.

The head is at its longest, vertically, when it's straight and looking forward without any tilt. When it's tilted up or down, it appears to compress and gets slightly shorter.

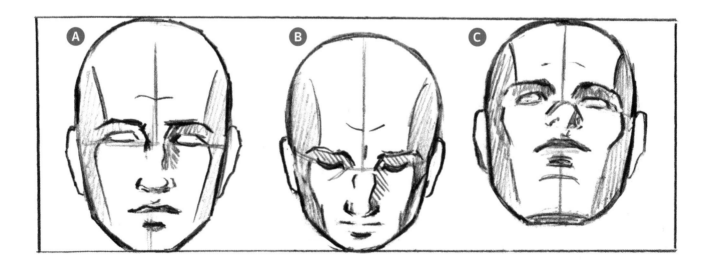

A No tilt **B** Downward tilt—features are compressed **C** Upward tilt—features are compressed

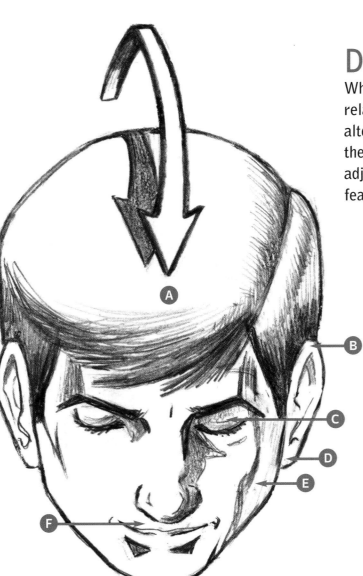

Downward Tilt

When the head tilts downward, the relationships among the features are altered in predictable ways. The greater the tilt, the greater the change. Without adjusting the relative positions of the features, this angle is impossible to draw.

A The top of the head appears to take up more area.

B In a downward tilt, the ears appear higher than the eyebrows.

C The eyebrow is drawn closer to the eye.

D The bottoms of the ears are higher than, instead of the same height as, the tip of the nose.

E Both side planes of the jaw converge sharply toward the chin.

F The space between the tip of the nose and the lips shrinks.

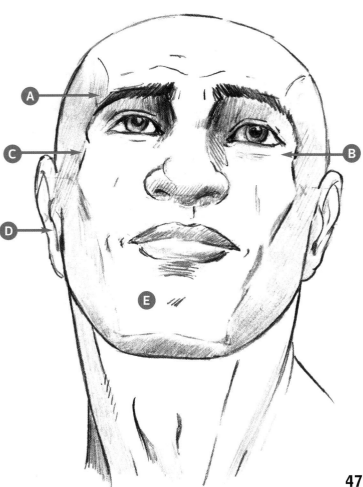

Upward Tilt

The opposite effects are seen when the head tilts back or upward rather than downward.

A The eyebrows are higher than the ears.

B The bottom eyelids tend to flatten out.

C At this angle, the cheekbone appears higher than the ear canal. At a neutral angle, they're on the same level.

D The ear canal may not be obvious in the front view, but its location can be inferred by the tragus, which is the small earflap that covers it.

E The chin appears to take up more area and the forehead less.

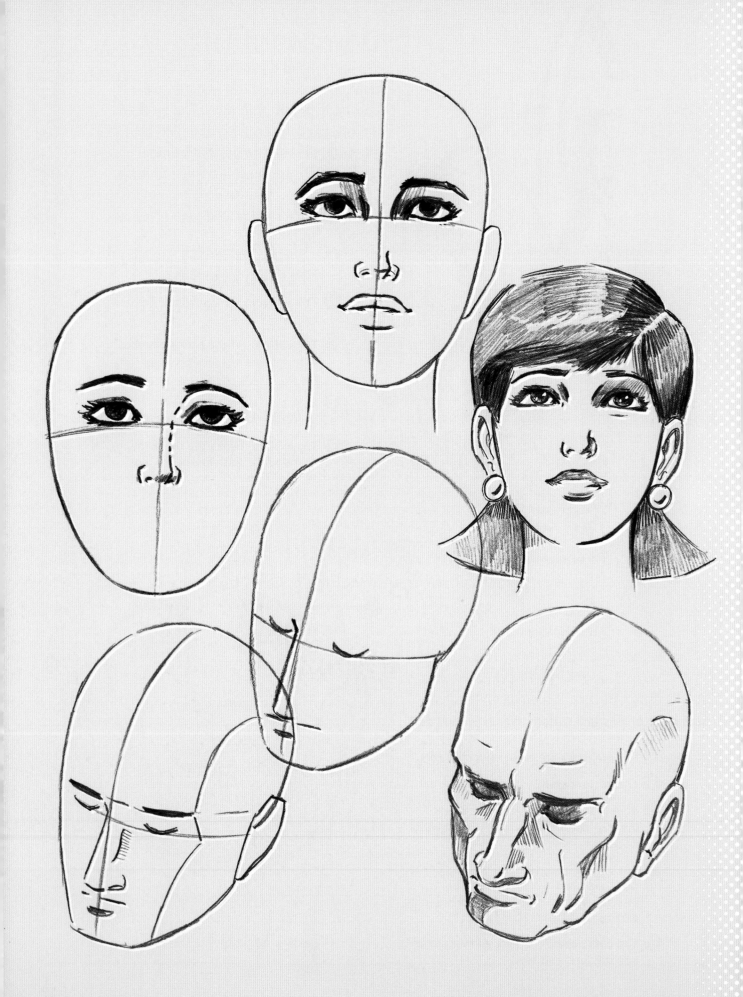

Step-by-Step Tutorials: The Head

Before you begin drawing these tutorials, I'd like to offer a little perspective on this subject. Proportions are only a set of guidelines. Give yourself the freedom to draw unfettered by a huge number of considerations other than the basic proportions.

When you've completed your rough drawing, then it's time to check and adjust the fine points. Many of the mental notes you've made along the way—for example, that the eyes are located halfway up the head—will become instinctive. The more often you draw with the correct proportions, the less often you'll need to check them. It will become intuitive.

Neutral Front View

Many beginners try drawing the front view before they attempt to tackle the ¾ view or profile. That's because the front view appears to be the easiest. Actually, it may be the most difficult. In the neutral position (the front angle), not only is everything symmetrical but everything is in plain sight, and all the elements are prominent. Therefore, mistakes are obvious in this pose. If you use the correct proportions and guidelines, the placement of the features becomes easy.

A Eye line

B Center line

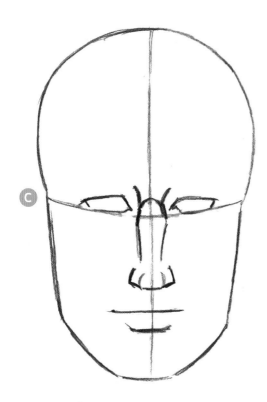

C The eyes rest on the eye line, equidistant from each other.

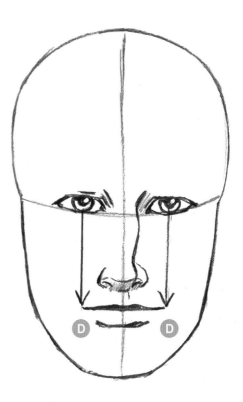

D Find the width of the mouth by using the pupils as a guide.

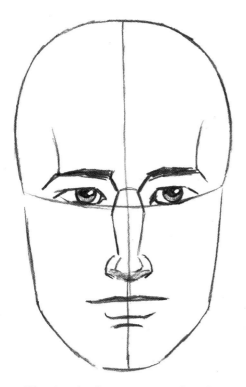

The basic features are in place.

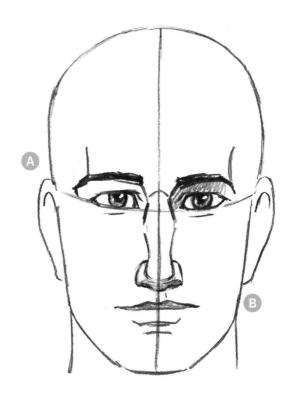

A The tops of the ears line up with the eyebrows.

B The bottoms of the ears are level with the bottom of the nose.

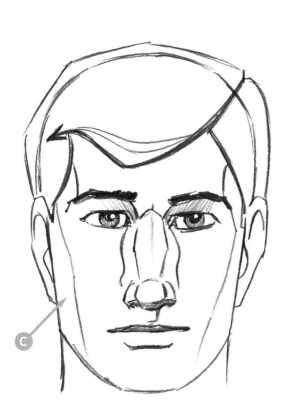

C Side plane of face

It's best to adjust the proportions before rather than after adding shading. Shading can make features appear larger than they actually are.

Front View, Slight Up Tilt

This upward angle conveys a feeling of wonderment, hope, and optimism. Here, the eyes are positioned above the midpoint of the head, due to the effects of perspective as a result of the tilt of the head. We're looking slightly up at the figure's upper lip, up at the bottom of her nose, and up at the pockets under her eyebrows.

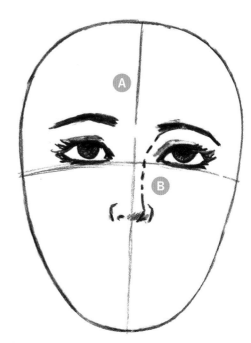

A The slight up tilt of the head reduces the apparent size of the forehead.

B Curve the eyeline downward to convey the roundness of the head.

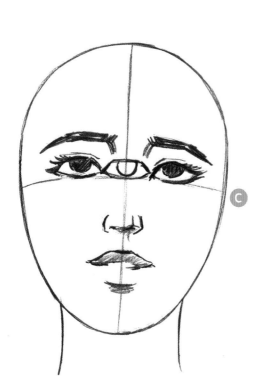

C Pause to check the placement of the eyes, which should be 1 eye length apart.

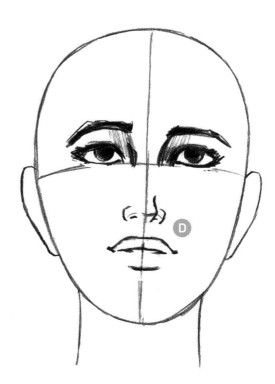

D This angle should reveal more of the underside of the nose.

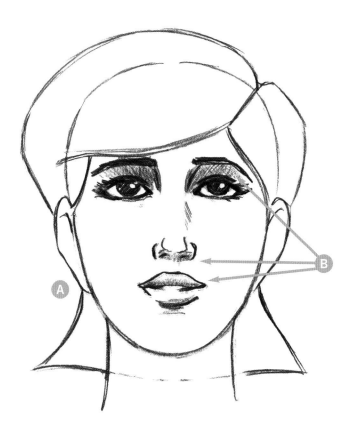

A Because of the upward tilt of the head, the ears appear lower than the eyes.

B Facial features that either protrude or recede from the plane of the face are shaded when there is overhead lighting. These elements include the eyebrow pockets under the eyes, the underside of the nose, and the upper lip.

Proportion Hint: Up Tilt

When the head tilts in the up position, the bottoms of the eyes tend to flatten slightly.

The front view is very symmetrical. Use the center line and the eye line to maintain balance among the features.

Profile

The profile has sharply defined angles, like a silhouette, and the outline of the features is most prominent.
- The back of the skull takes up a substantial percentage of the head.
- The ear is at the center (as measured from front to back).
- The front plane of the face is indicated by a flat guideline.

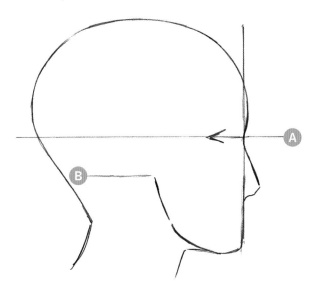

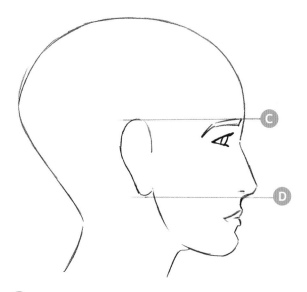

A The eye is halfway up the head.

B Bottom of cranium

C The top of the ear and the eyebrow are at the same level.

D The bottom of the ear and the bottom of the nose are at the same level.

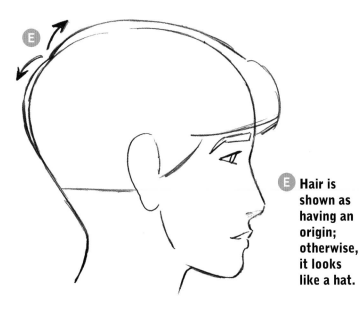

E Hair is shown as having an origin; otherwise, it looks like a hat.

Profile Proportion Hint #1

An important axiom for profile proportions, which is covered in the beginning of the book, comes into play now:

In the profile, the head is as tall as it is wide.

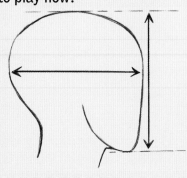

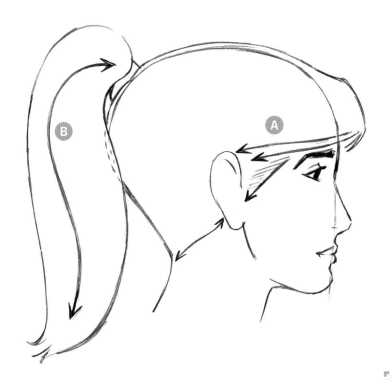

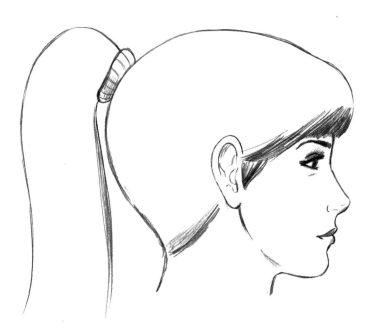

A The hair direction is pulled toward the back of the head due to the ponytail.

B The ponytail itself flows in a subtle S curve.

The eye and lips in the profile view don't appear to be as long as in the front view.

Profile Proportion Hint #2

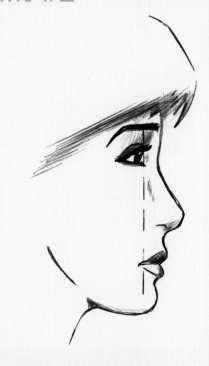

In profile, the corner of the mouth and the front plane of the eye are even, vertically. (More expressive mouth positions, such as smiles, will cause the lips to move deeper into the face.)

Principles for Drawing the ¾ Angle

Before you draw the ¾ angle of the head (see opposite), let's get a quick overview of the landscape, which has changed in two fundamental ways. In the ¾ view (as opposed to the neutral front view and the profile), you now must indicate: (1) that the head appears rounded, as if it has depth; and (2) that the far side of the face compresses slightly due to the effect of perspective (which has a particularly strong effect on the far eye).

The guidelines—the center line and the eye line—curve as they wrap around the head.

In the front view, both eyes are of equal width.

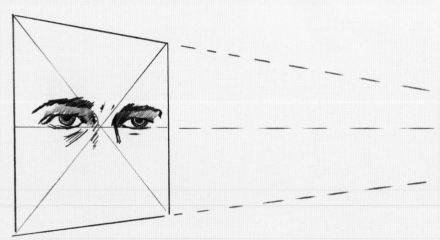

In the ¾ view, the effect of perspective causes the far eye to diminish in size. The adjustment may be subtle, but it's important.

Drawing the ¾ Angle, Facing Left

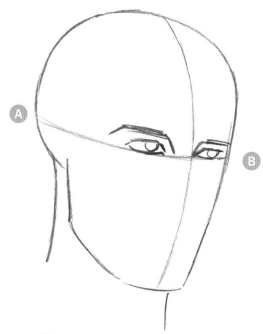

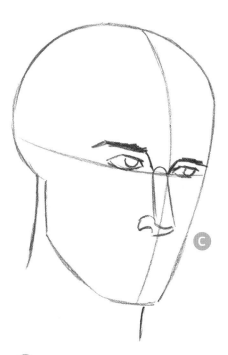

A The center line and the eye line curve in the ¾ view to convey the roundness of the head.

B Notice, too, that the far eye is somewhat smaller than the near eye.

C The nose protrudes outward at a 45-degree angle from the center line.

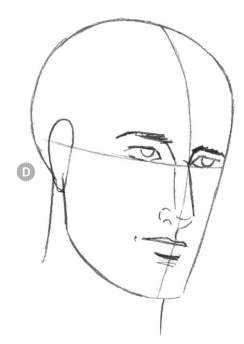

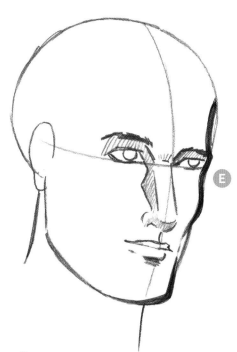

D Due to the slight downward tilt of the head, the near ear appears a little higher on the head, just above the level of the near eyebrow.

E The brow protrudes and then indents as it becomes the orbit of the eye.

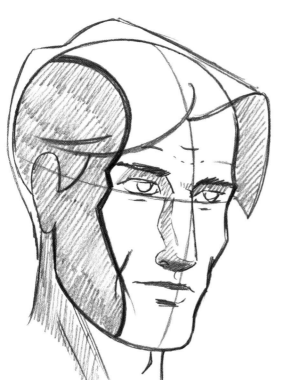

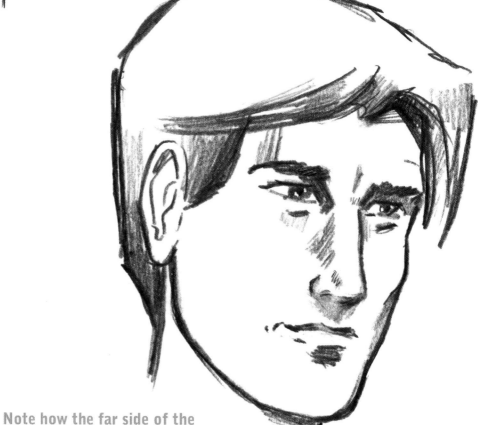

Proportion Hint

By articulating the planes of the head and features, you get a sense of the form you're sketching. In your final drawing, you will erase the lines that define the planes of the face. So why draw them in the first place? Because they help create a solid, well-thought-out construction.

Note how the far side of the face is more articulated than the near side in the ¾ view.

Drawing the ¾ Angle, Facing Right

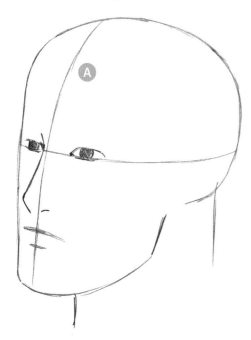

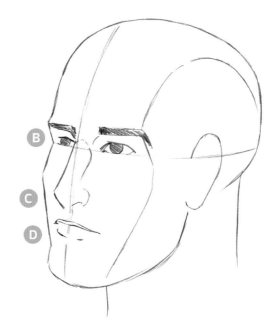

A The center line runs from the crown of the head, down the bridge of the nose, to the bottom of the chin.

B The far eye is cut off by the bridge of the nose.

C The nose protrudes outward into the far area of the face.

D The far side of the mouth appears shorter than the near half.

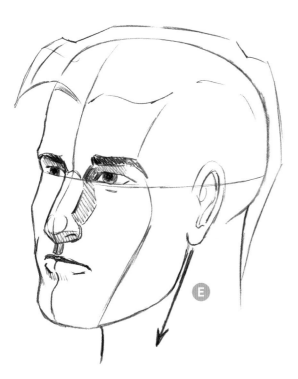

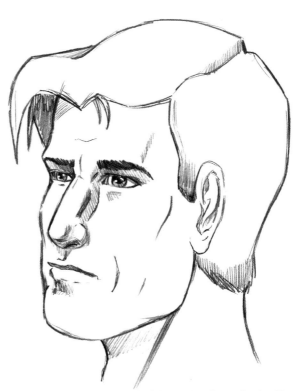

E The jaw angles inward on a slight diagonal.

The nose divides the face in half. Because it overlaps the far side of the face, it conveys a sense of depth.

¾ View, Down Tilt

A downward tilt of the head is the same as looking at the head from above. As with any object seen in perspective, the nearer parts appear larger and the farther parts appear smaller. This results in a compressed look.

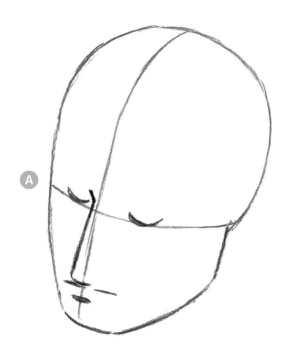

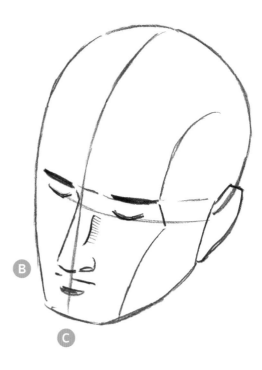

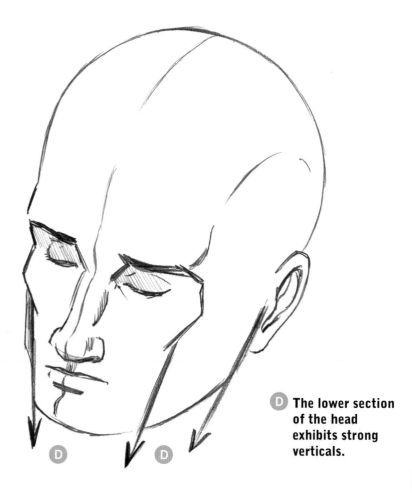

A Due to the effects of perspective, the eye line appears lower than the midpoint of the head, where it normally is. In the down angle, the eye line also curves up at the ends.

B From this angle, the nose almost seems to overlap the mouth.

C The chin appears compressed.

D The lower section of the head exhibits strong verticals.

60

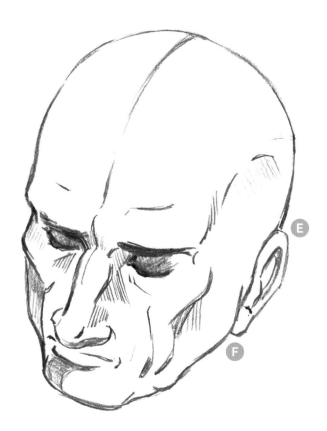

E The top of the ear is above the eyebrows; in a neutral view, it's at the same level.

F When the head tilts down, the angle of the jaw falls at a point higher than the level of the mouth; in a neutral position, it's at the same level.

Proportion Hint: Nose Tilts

When the head tilts up or down, the nose appears slightly shorter.

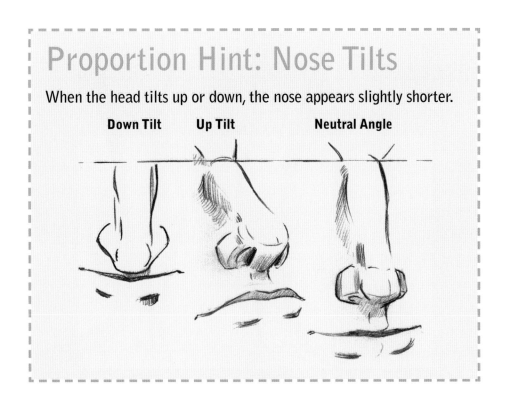

| Down Tilt | Up Tilt | Neutral Angle |

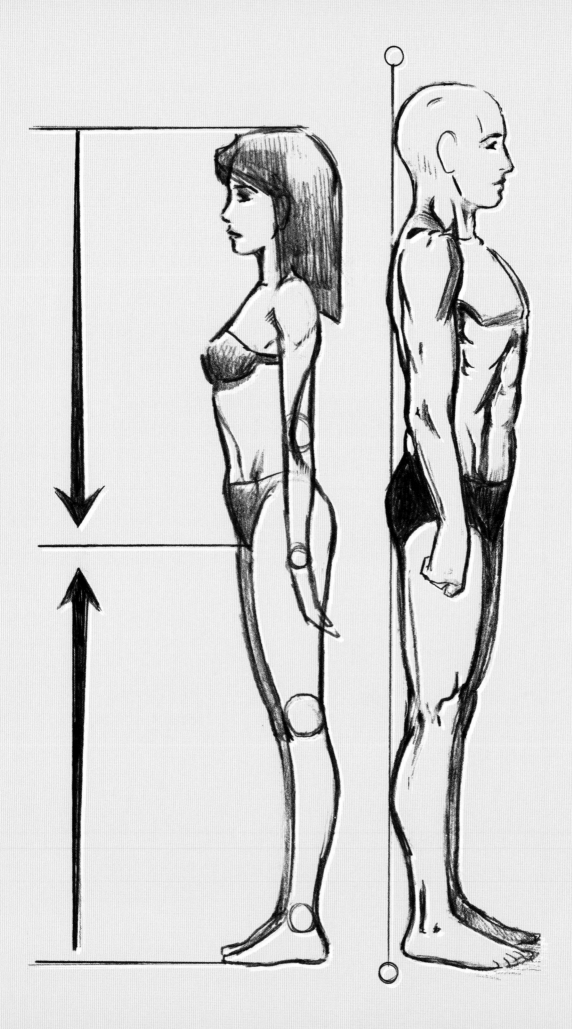

The Body: Overall Measurements

The use of basic proportions helps demystify the complex machine that is the human body. Drawing the body without understanding the relationships among its parts is like building a house brick by brick, without an architectural plan. The primary proportions of the body are height and width. More detailed proportions define the major segments of the body, such as the arms and legs. There are also often overlooked proportions that measure the body's interior points, such as the height of the chest and the level of the navel.

It's important to establish the primary proportions from the beginning because they affect one another like dominoes. For example, a vertical halfway point that's too high would cause the torso to appear too short, and the arms and legs too long. To avoid this, we begin with the larger, overall proportions, locking the basic framework in place before attacking the details.

Height and Proportions: Male/Female Comparison

This entire section will give you a solid foundation for drawing the body. First, however, we'll establish what I call the "framework" proportions and then work our way down to specific sections of the body, limbs, and muscle groups. This approach is also excellent for most types of drawing: Progress from the general to the specific.

Male Height and Proportions

To arrive at the correct height, we use the head as a unit of measurement; therefore, we speak in terms of how many "heads tall" a figure is, rather than using feet and inches.

The average person is 7 to 7½ heads tall. This is a somewhat flexible proportion in that half a head, more or less, won't affect the overall look of the proportions.

Notice that each unit of measurement is equal to the length of the head on this figure.

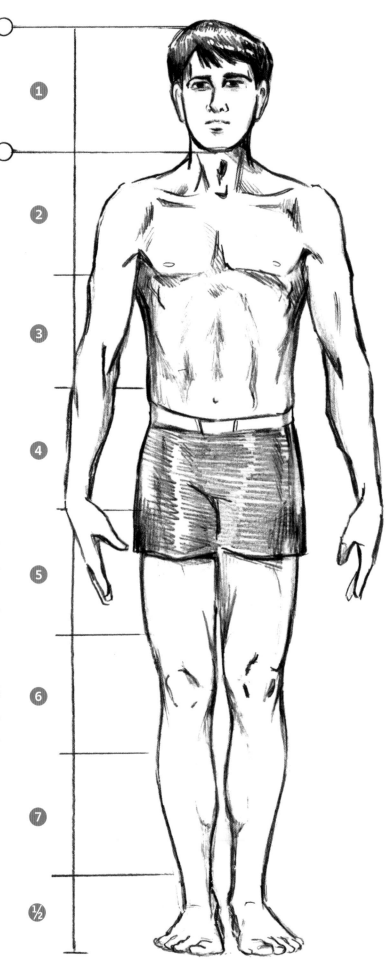

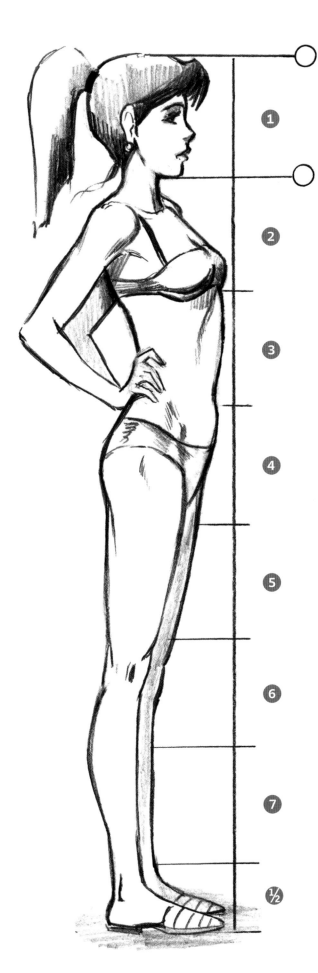

Female Height and Proportions

The average female is also 7 to 7½ heads tall; however, her overall height is approximately half a head shorter than that of a man.

Height Comparison

Although individuals vary, the average height difference between a man and a woman is half a head. Remember that the eye/bridge-of-the-nose axis represents the halfway point of the head.

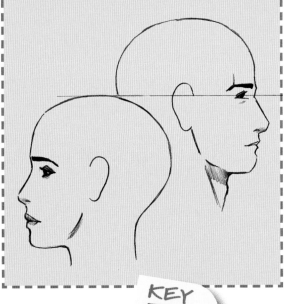

KEY POINT

The female figure is generally half a head shorter than the male figure.

Height on the female figure is also measured in heads.

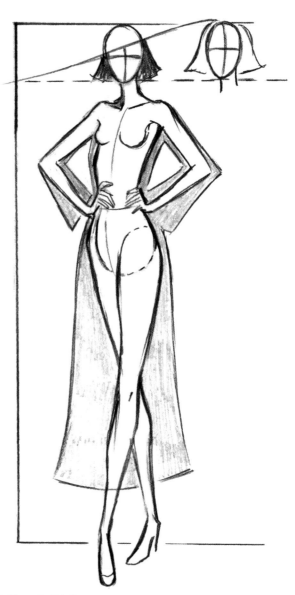

Using Height to Convey Stature

Illustrators often exaggerate the height of a figure to give it a commanding presence or a stylish flair. Rarely, though, is the height decreased below 7½ heads tall as a stylistic choice.

8 Heads Tall

This heroic height is often found in comics and fantasy illustrations.

9 Heads Tall

Figures in fashion drawings are typically 9 to 12 heads tall. The point isn't to be realistic but to show long lines, which give the image a stylish look.

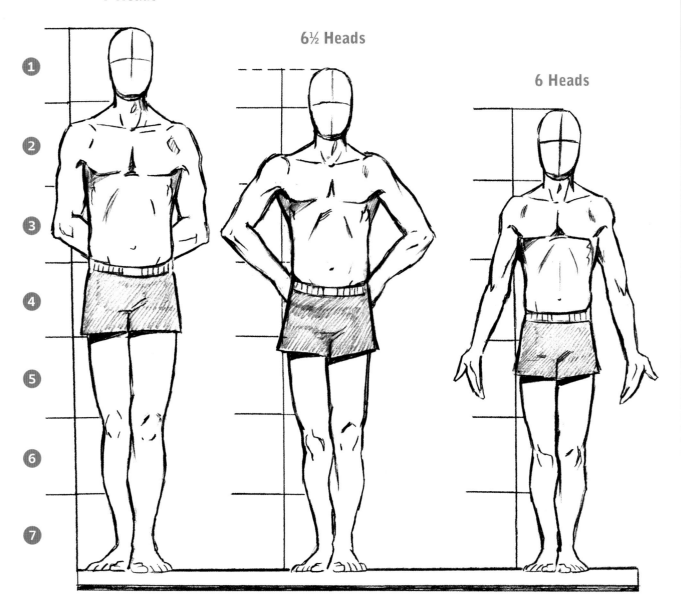

7 Heads

6½ Heads

6 Heads

Variations in Height

From the examples, you can see that as you shorten the proportions from the average 7½ heads tall to 7 heads tall, not too much appears to change; however, as you continue down to 6½ heads and finally to 6 heads, the figure becomes more modest in appearance.

Body Length

This proportion is more conceptual than it is practical in actual drawing. The armspan equals the overall height of the figure. Notice how long the limbs are in relation to the body—they require a lot of length in order to appear correctly proportioned.

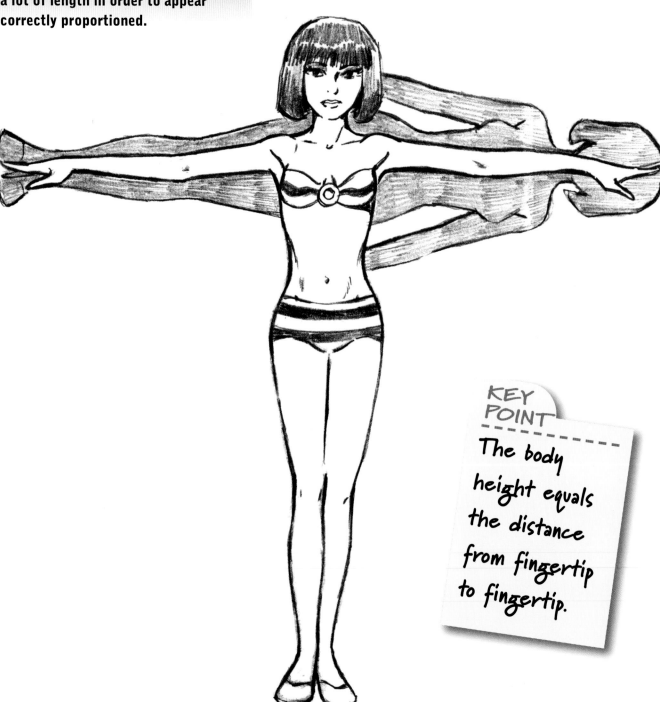

KEY POINT

The body height equals the distance from fingertip to fingertip.

The Halfway Point

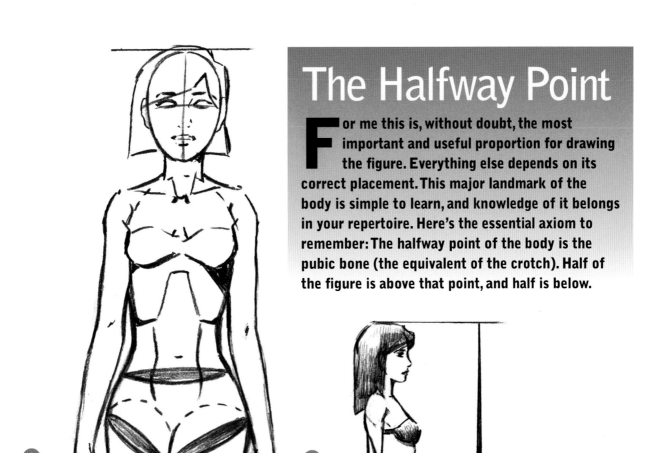

For me this is, without doubt, the most important and useful proportion for drawing the figure. Everything else depends on its correct placement. This major landmark of the body is simple to learn, and knowledge of it belongs in your repertoire. Here's the essential axiom to remember: The halfway point of the body is the pubic bone (the equivalent of the crotch). Half of the figure is above that point, and half is below.

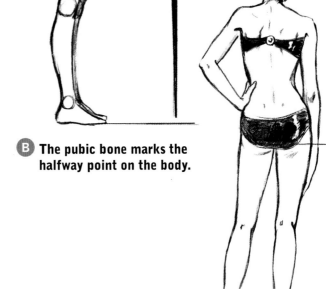

B The pubic bone marks the halfway point on the body.

A Halfway point: There's an equivalent amount of length above and below this line.

C The halfway point in the rear view is slightly below the tailbone.

Head and Body Width

Shoulder muscles can be large or small, depending on the muscular development of the person. This gives us a little room to be approximate; nonetheless, the standard proportion is three to one: 3 head widths equal the shoulder width. Note: Don't include the ears when you measure the width of the head for proportion purposes.

Measure this from the outside of the left shoulder to the outside of the right shoulder, with the arms down at the sides.

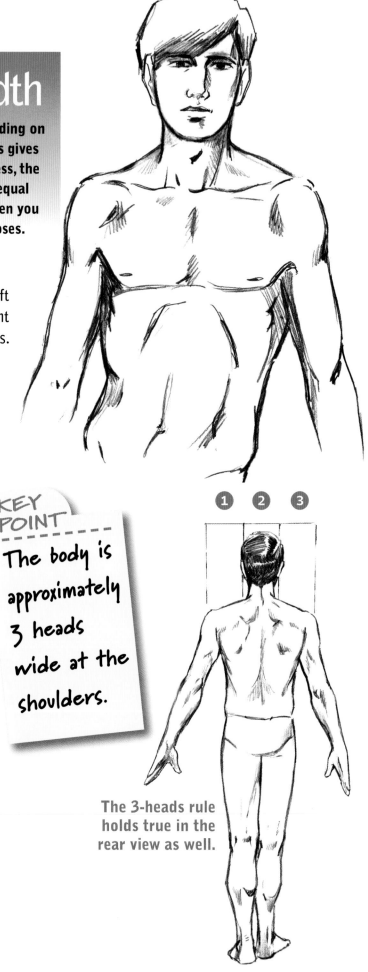

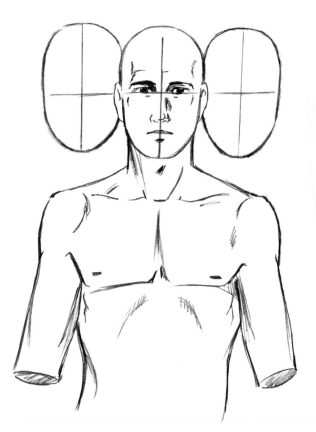

The most reliable way of checking the width of the body is to align the heads side by side. If the heads appear wider than the shoulders, you may have to increase the width of the body. But not always. There are some exceptions, as we'll see coming up.

KEY POINT

The body is approximately 3 heads wide at the shoulders.

① ② ③

The 3-heads rule holds true in the rear view as well.

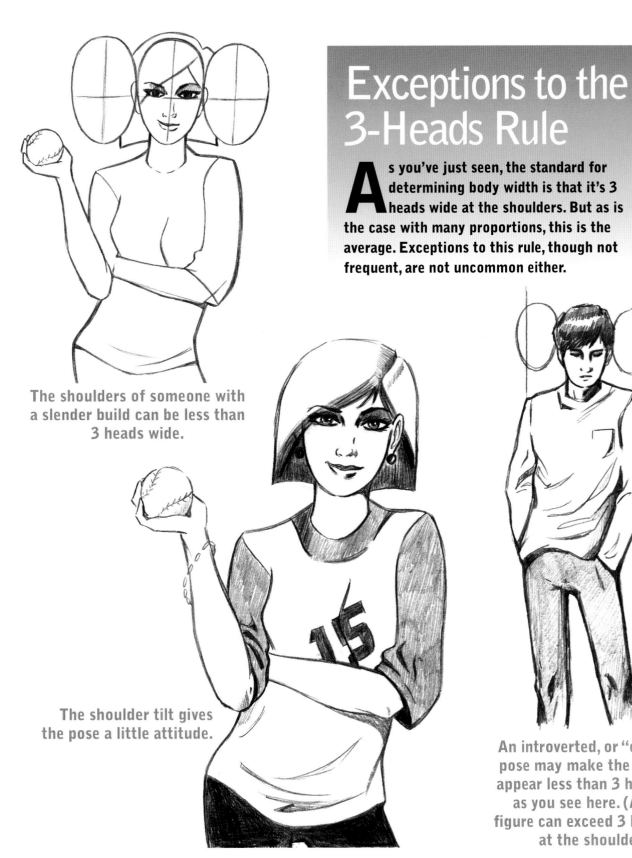

Exceptions to the 3-Heads Rule

As you've just seen, the standard for determining body width is that it's 3 heads wide at the shoulders. But as is the case with many proportions, this is the average. Exceptions to this rule, though not frequent, are not uncommon either.

The shoulders of someone with a slender build can be less than 3 heads wide.

The shoulder tilt gives the pose a little attitude.

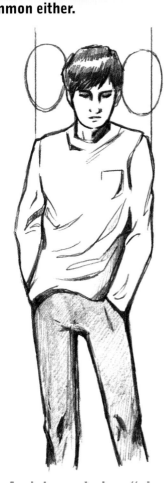

An introverted, or "closed-in," pose may make the shoulders appear less than 3 heads wide, as you see here. (A heroic figure can exceed 3 heads wide at the shoulders.)

For example, some introverted poses create the appearance that the body is less than 3 heads wide. And some people, men and women alike, have a slender build, which results in their heads taking up a slightly greater fraction of the standard distance; or, put another way, their bodies are slightly less than 3 heads wide. Athletes may have wider builds, and so on. In addition, sometimes artistic liberties are taken to create a specific look.

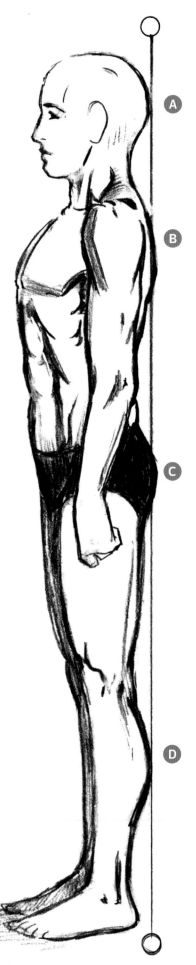

Posture and Proportions

The definition of *proportion* is the relative sizes of objects or areas and the relationships between them.

But there's only one spine, so what are we going to compare it with? We're going to use a vertical guideline as the basis from which to make our observations.

Classic good posture is not a perfectly straight back. There's no such thing, since the spine is naturally curved; however, we can safely say that good posture does depend on certain points along the body aligning with a vertical guideline. Good posture is where the back of the head, the upper back, and the buttocks and calf muscle are aligned fairly evenly along a vertical plane. Not everyone stands with classic posture, but this is the baseline. Your mom was right: Stand up straight and don't slouch.

A Back of head

B Upper back

C Buttocks

D Calf muscle

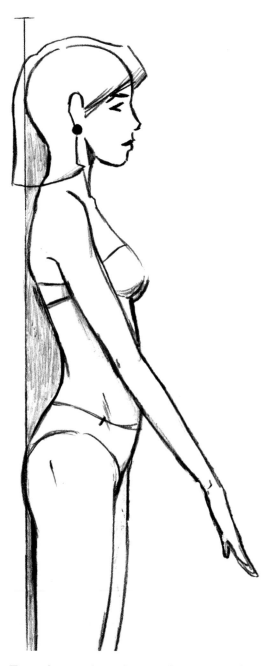

Even in a relaxed standing pose, the figure comes close to adhering to the vertical guideline.

72

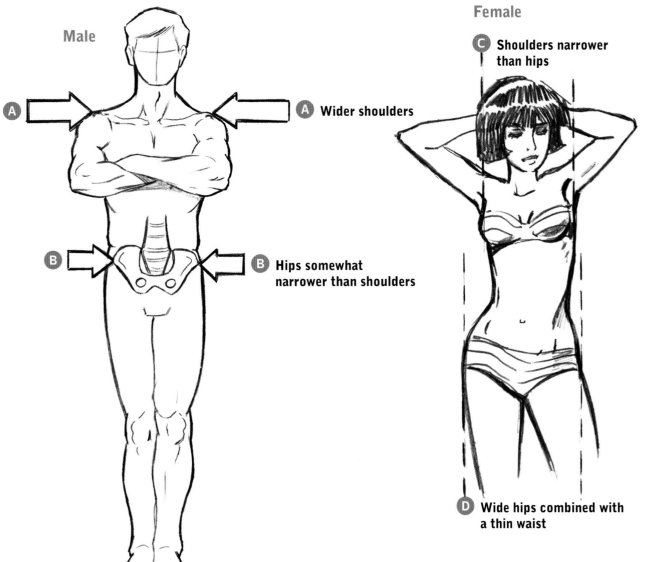

Male

A Wider shoulders

B Hips somewhat narrower than shoulders

Female

C Shoulders narrower than hips

D Wide hips combined with a thin waist

Shoulder-to-Hip Ratio

The shoulder-to-hip ratio is key to capturing the differences between male and female figures. This difference in proportion isn't solely due to the fact that the average man's shoulders are wider than the average woman's shoulders. It also comes from the fact that the average man's hips are smaller than his shoulders. The shoulders on women are slightly narrower than their hips. Therefore, the female shoulder-to-hip ratio is the reverse of the male shoulder-to-hip ratio: Men's shoulders are wider than their hips, while women's hips are wider than their shoulders.

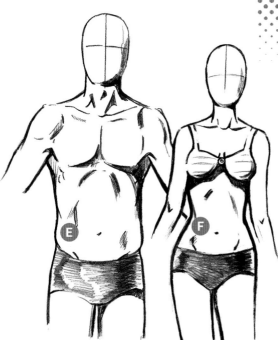

E Thicker but lower waistline

F Thinner but higher waistline

73

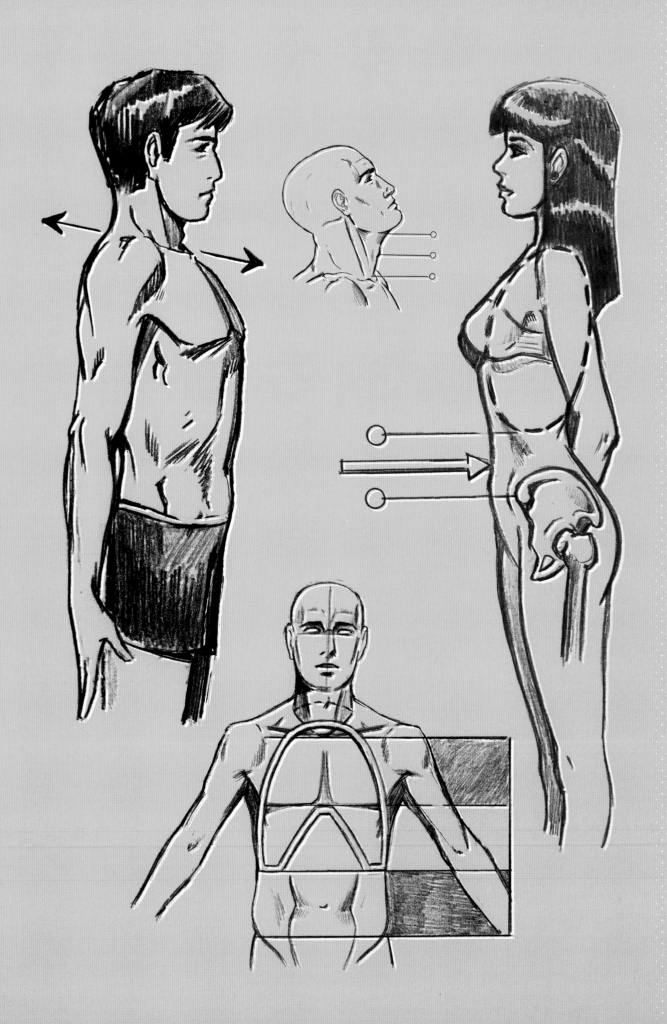

The Torso

Now we turn to individual areas of the body, such as the neck, chest, abdomen, hips, arms, hands, legs, and feet. In this chapter, we focus on the torso. As important as it is to know the approximate proportions of each section of the body, it's equally important to understand the relationship of the proportions of one section of the body to another. Therefore, we'll reference different "landmarks" of the body that are prominent or specially situated, so as to have easy-to-find benchmarks for accurate proportions.

Details, sometimes seemingly trivial ones, can seriously impair a drawing if they're out of proportion. Take the human navel as an example. Out of context, it's a mere detail, but if it's placed too high on the torso, it tends to make the entire figure look somewhat truncated and stocky.

Neck Width

A common problem among beginners is drawing the neck too thin. A poorly proportioned neck has the unfortunate luck of being in the place most likely to be noticed: near the head. Therefore, let's get this simple proportion right from the start: A man's neck is the width of the angle of the jaw; on women, it's slightly narrower.

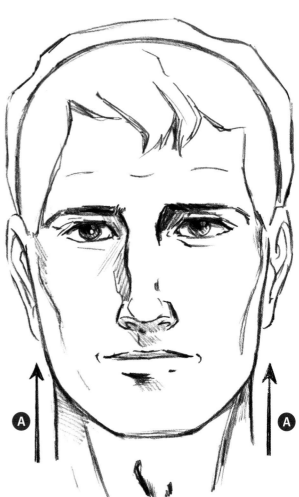

A On men, the neck is fairly flush with the width of the jaw.

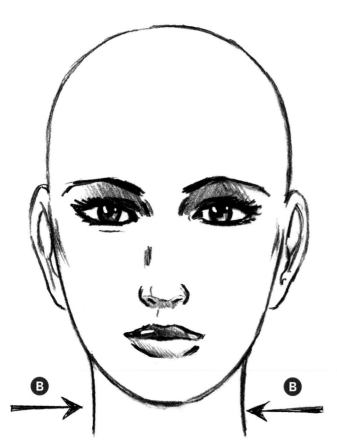

B On women, the neck indents slightly from the perimeter of the head.

The Adam's Apple

A bothersome little part, the Adam's apple moves up and down while a person talks, and therefore, many artists are uncertain of its placement at rest. (The technical term for the Adam's apple is *prominentia laryngea*, or laryngeal prominence.) The degree to which it protrudes varies from person to person. To find its correct location, you first find the halfway point from the chin to the pit of the neck. The Adam's apple goes on or just above the halfway point.

When the Head Tilts

When the head tilts back, the neck lengthens under the jaw, something that doesn't happen when the chin is down. This causes the Adam's apple to lower slightly on the neck, resting exactly at the halfway point instead of above it.

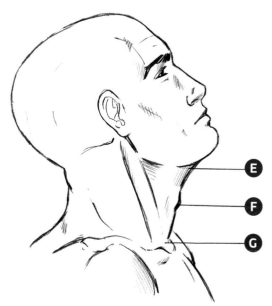

E Lifting the chin reveals more neck length.

F The halfway point of the neck shifts, becoming higher than it is when the head is in a neutral position.

G As a result, the Adam's apple appears slightly lower on the head, either directly at the halfway point or slightly below it.

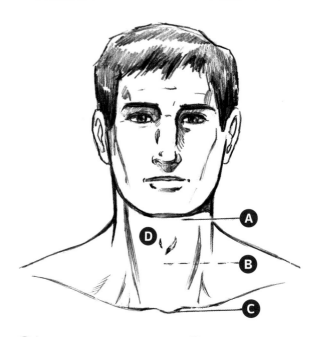

A Bottom of chin

B Halfway point of neck

C Pit of neck

D Adam's apple

KEY POINT

The Adam's apple is slightly higher than the halfway point of the neck.

Women & the Adam's Apple

The Adam's apple doesn't show on women.

77

The Angle of the Neck

Neck proportions are important for drawing profiles as well as ¾ views. Start off by locating the seventh vertebra of the spine, which is the large, knotty bone at the base of the rear of the neck. You can feel it with your fingers. Draw a sloping line from the seventh vertebra down to the pit of the neck. This is a good way to maintain asymmetry between front and back.

When creating guidelines, it's helpful to draw a disk that angles downward to represent the base of the neck.

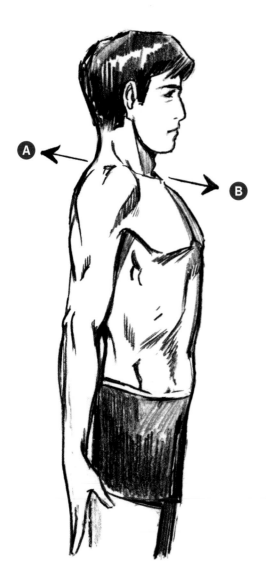

A ← Seventh vertebra

B → Pit of neck (where collarbones meet)

KEY POINT

The neck appears higher in back than in front.

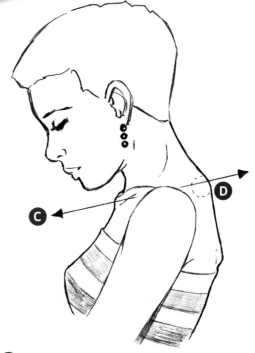

C Note the angled line that runs from the front to the back of the neck.

D The dotted circle represents the seventh vertebra.

The Chest

The chest is perhaps the most prominent feature of the torso. It imparts a presence and stature. If the chest is drawn too high, the figure appears weak. Drawn too low and the figure appears flabby or even brutish. To find the correct chest proportions, keep the following guideline in mind: There's approximately 1 head length from the bottom of the chin to the bottom of the chest muscles.

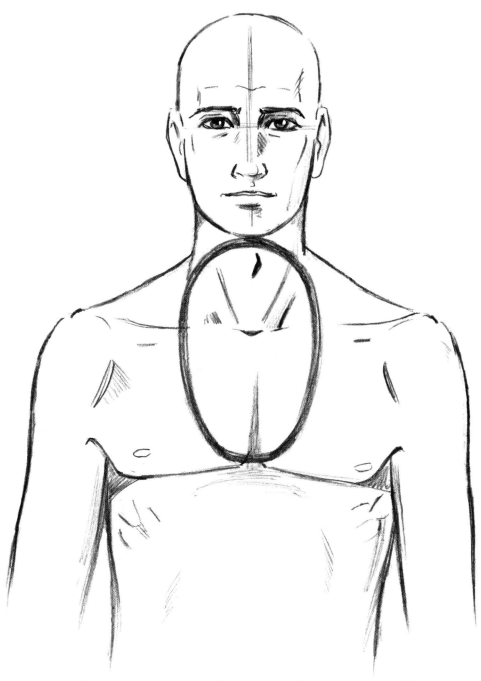

From the bottom of the chin to the bottom line of the chest is 1 head length.

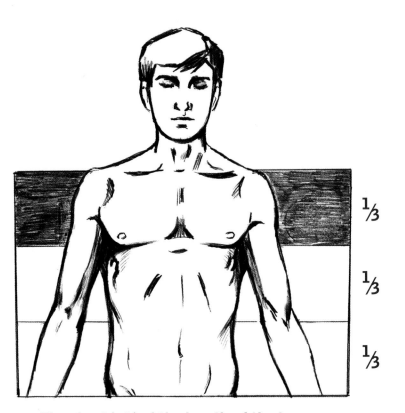

Chest Proportions

A second method of establishing correct chest proportions is to divide the torso into thirds. Personally, I prefer this method, as it determines the proportion of the entire torso.

⅓

⅓

⅓

The chest is ⅓ of the length of the torso, as measured from the top of the shoulders (*acromion*) to the hip bone (*crest of the ilium*).

The nipples are below the level of the armpits.

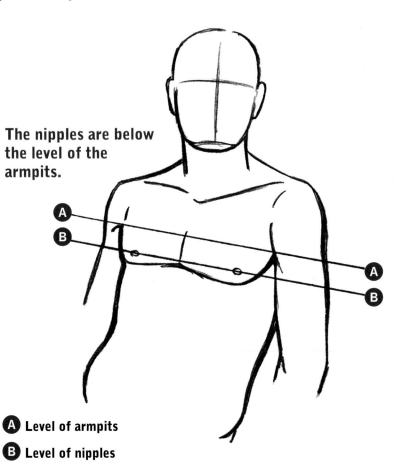

Ⓐ Level of armpits

Ⓑ Level of nipples

The Shape and Size of the Chest Muscles

The development of the chest muscles depends on the individual. Nonetheless, a useful key point for getting the overall shape is that the bottom of the chest is not a straight, horizontal line. It's a curved, sloping line.

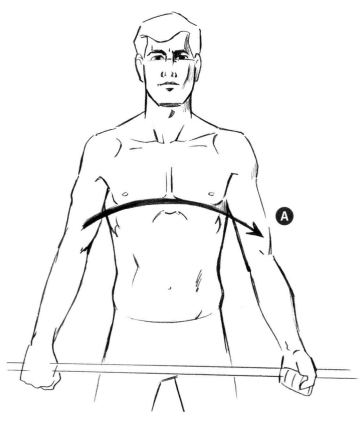

A Line of chest

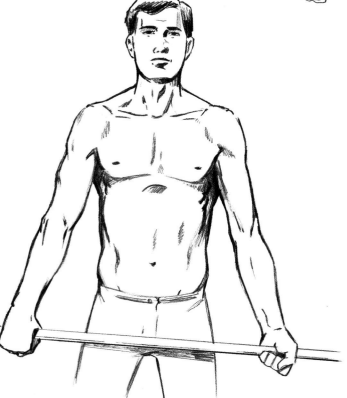

The downward curve of the chest muscles is most prominent on individuals with clear muscular definition.

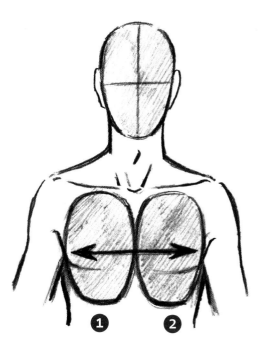

The chest is 2 heads wide.

81

The Chest and Rib Cage

The rib cage provides one of the most useful landmarks for measuring proportions. Look to the torso to get the framework for measuring the rib cage length. The torso is considered the area from the pit of the neck to the hip bone (*crest of the ilium*), and the rib cage takes up ⅔ of the torso.

Notice that the rib cage comes up slightly higher than the pit of the neck in the illustration here. Most people don't realize how long the rib cage is or that it rises above the base of the neck.

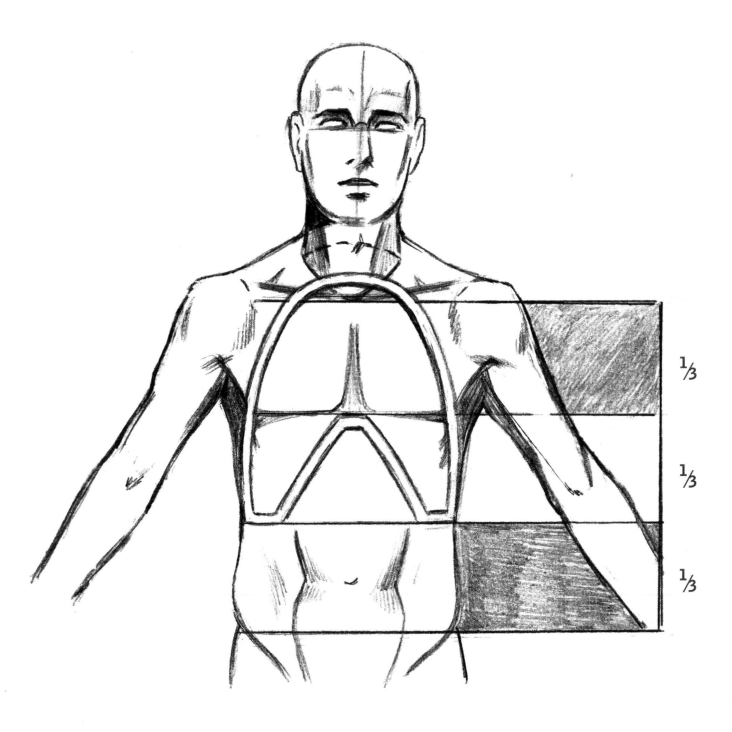

⅓

⅓

⅓

The Hollow of the Rib Cage

The hollow of the rib cage provides the framework for the abdominal muscles. To locate the hollow, use the sternum. The sternum, which begins at the pit of the neck, is a flat bone that fuses together both sides of the rib cage. It's 1 hand length long. The hollow begins where the sternum ends.

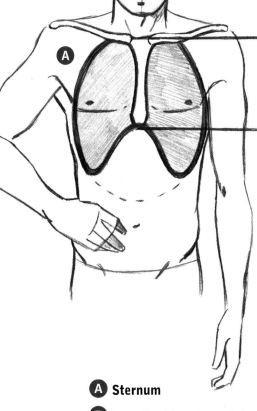

A Sternum

B Length of hand equals length of sternum

KEY POINT

The sternum is 1 hand length long.

A slight bit of shading is all that's needed to indicate the sternum.

Placement of the Navel

No other detail causes so much confusion as the navel, yet it's important to the overall look of the figure. As the only feature on an otherwise largely undefined area of the torso, it is curiously prominent.

Here's an empirical way to arrive at the correct location of the navel: The navel appears halfway between the bottom of the rib cage and the bony knobs at the top of the hips (*the iliac crest*).

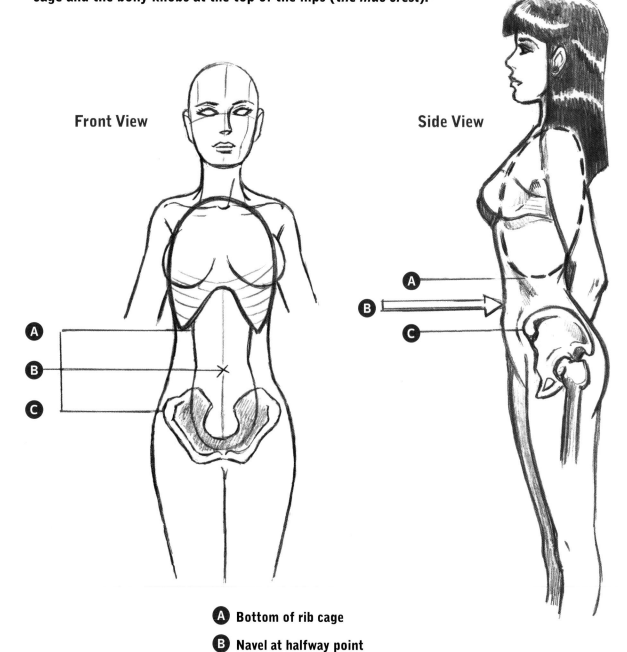

Front View

Side View

(A) Bottom of rib cage

(B) Navel at halfway point

(C) *Iliac crest* (note that the crest is a knobby bone, which makes it easier to locate both visually and by touch)

The Navel in Relation to the Abs

The abdominal wall has four pairs of muscles, which are stacked vertically one pair above another. Most often, only the bottom three sets of muscles are visible through the surface of the skin. The top set is small and not apparent unless the individual is very fit.

The muscles in the bottom pair are the longest of the goup. They're our landmark for the navel, providing another method of finding the placement of this feature, because the navel is located just under the top of this set of muscles. However, placing the navel directly on the top edge of this last set of abs will look as correct as placing it just beneath that point.

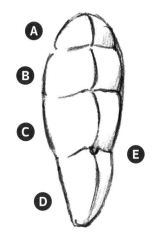

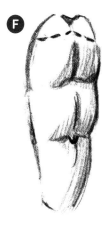

A 1st pair

B 2nd pair

C 3rd pair

D 4th—and longest—pair

E Navel

F The top set of abdominal muscles is usually not apparent at the surface of the skin.

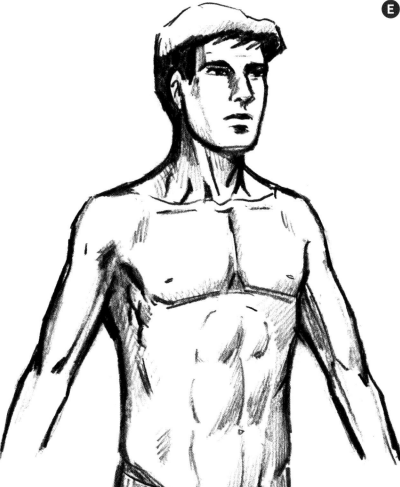

KEY POINT

The navel is placed at, or just under, the top edge of the bottom set of abdominal muscles.

The Two Essential Landmarks of the Torso

There are two torso landmarks that are useful for establishing a number of proportions. In fact, you've already used them several times. Now let's have a closer look at them.

These two bony knobs, which are at both front ends of the pelvis just under the *external obliques*, are called the *crest of the ilium*. When you discover how useful these landmarks are, you'll want to use them as frequently as possible. Let's observe where they occur in relation to the torso.

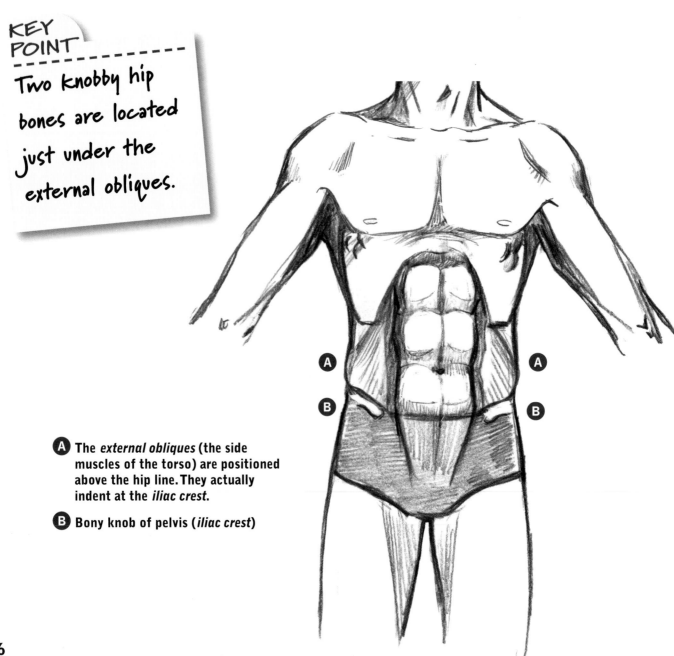

KEY POINT

Two knobby hip bones are located just under the external obliques.

A The *external obliques* (the side muscles of the torso) are positioned above the hip line. They actually indent at the *iliac crest*.

B Bony knob of pelvis (*iliac crest*)

The Widest Point of the Lower Body

The widest point on the lower body probably isn't where you think it is. The widest part is at the hips but not the top of the hips—it's at the bottom, where the thigh joint attaches to the pelvis. Knowing this often-overlooked but valuable proportion will add authority to your drawings. And it's especially helpful for poses that emphasize a tilt of the hips, which results from placing more weight on one foot than on the other.

KEY POINT

The widest part of the lower body is at the thigh joint.

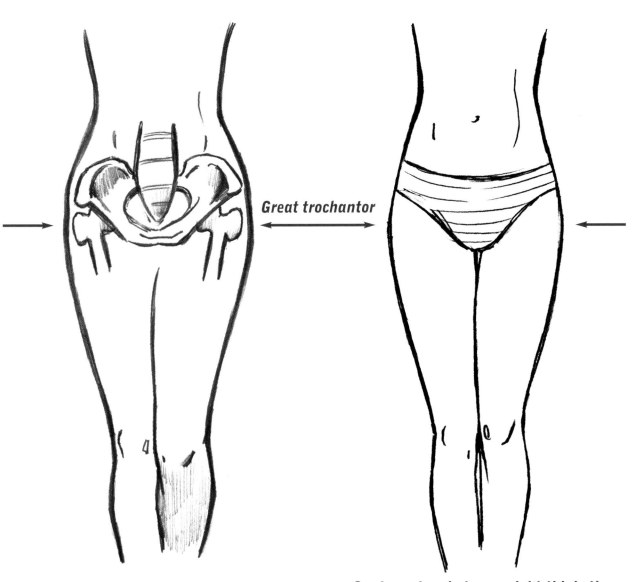

Great trochantor

The widest point of the lower body is where the large ball-and-socket joint of the thigh bone (the *great trochantor*) attaches to the bottom of the pelvis.

Contrary to what you might think, the upper part of the hips isn't the widest point on the lower body. Instead, it's the lower part of the hips, because the hips continue to widen until they reach the thigh joints, at which point they taper rapidly.

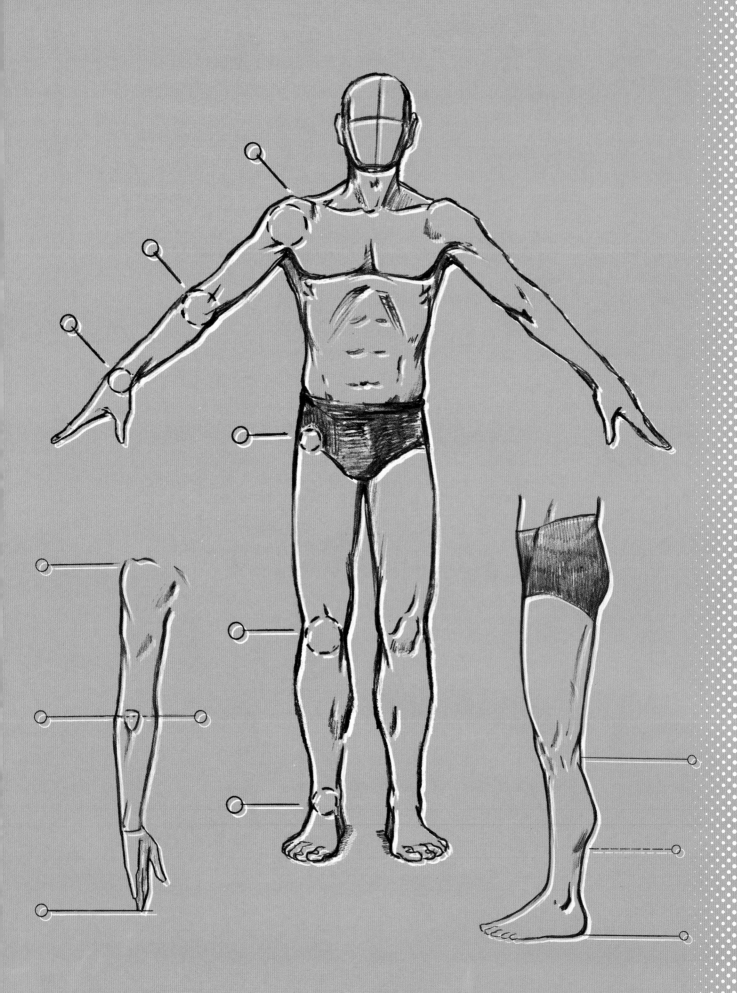

The Arms and Legs

There isn't an artist alive who hasn't struggled with the length of the arms or legs. This is partly due to the fact that the limbs have to be correctly proportioned twice: not only do they have to be in correct proportion to the body, but their upper parts must also be in correct proportion to their lower parts.

Arms and Legs: Overview

The following rule will enable you to add consistency to your drawings, removing the guesswork: The upper arms are longer than the forearms; likewise, the thighs are longer than the calves.

As a quick overview, the upper arm bone is the *humerus*. The forearm bone that attaches to the pinky side of the wrist is called the *ulna*. The forearm bone that attaches to the thumb side of the wrist is called the *radius*. The thigh bone is called the *femur*. The inner calf bone, which becomes the inner ankle, is called the *tibia*. And the outer calf bone, which becomes the outer ankle, is called the *fibia*.

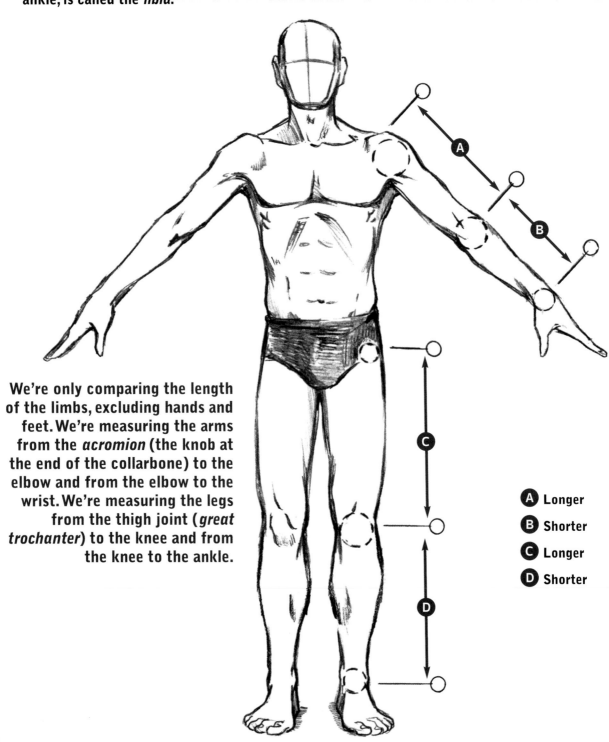

We're only comparing the length of the limbs, excluding hands and feet. We're measuring the arms from the *acromion* (the knob at the end of the collarbone) to the elbow and from the elbow to the wrist. We're measuring the legs from the thigh joint (*great trochanter*) to the knee and from the knee to the ankle.

A Longer

B Shorter

C Longer

D Shorter

Arm Proportions Excluding Hand

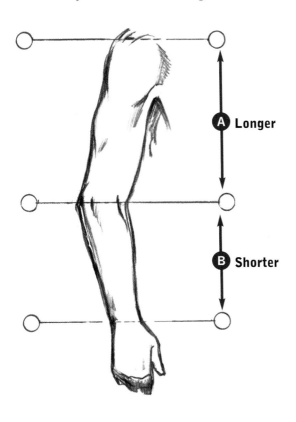

A Longer

B Shorter

Arm Proportions With and Without the Hand

The proportions of the arm can be checked in two ways: both with and without the length of the hand.

Arm Proportions Including Hand

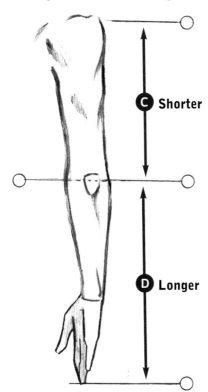

C Shorter

D Longer

Head Size Check

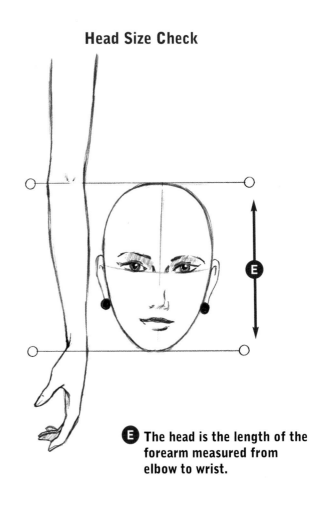

E

E The head is the length of the forearm measured from elbow to wrist.

The Level of the Elbow

This is a crucial benchmark that throws a lot of people. The elbows are level with the bottom of the rib cage. Just keep in mind that the contours of the torso suggest the placement of the rib cage on most people. If there's too much padding for that, remember that the rib cage is ⅔ of the torso, as measured from the pit of the neck to the hip bone.

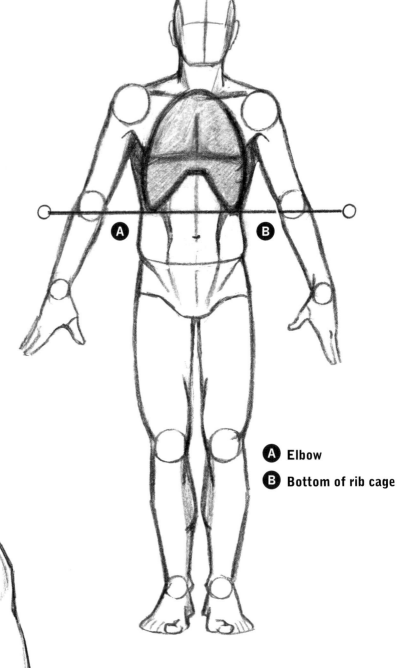

A Elbow

B Bottom of rib cage

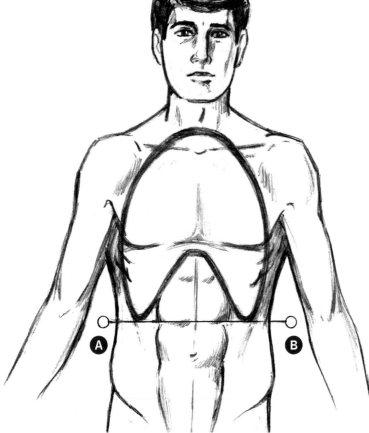

A Elbow

B Bottom of rib cage

KEY POINT

The elbows are level with the bottom of the rib cage.

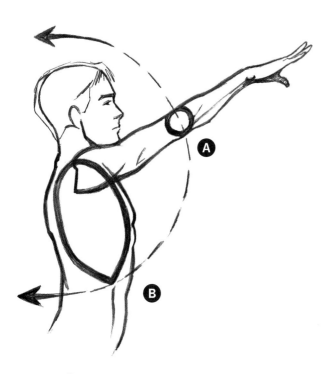

A Elbow

B Bottom of rib cage

The Elbow in Different Positions

We still need a method of arriving at the correct proportions when the elbow is away from the body. The simplest and quickest technique is to draw an arc from measuring point to measuring point. (Measuring points are the markers of the body used as units or points of comparison.) Here's how it works: Since the elbow is at the same level as the bottom of the rib cage when the arm is hanging at the sides, draw an arc from the bottom of the rib cage to the elbow.

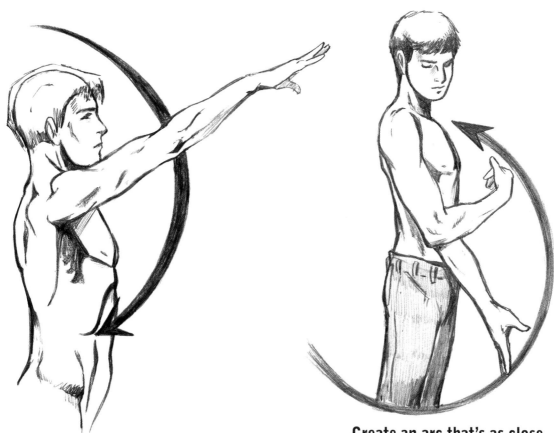

Arcs help to establish the range of motion for the limbs.

Create an arc that's as close in shape to a circle as possible.

What to Do When the Arm Is Bent

We know how to check the proportions when the figure's arms are held straight out or down. But people don't carry themselves that way all the time. So how do you arrive at the correct proportions when the arm is bent?

It's not that complicated. Here's how to do it: Draw a vertical guideline where the arm would be if it were hanging straight down at the side of the body. Place marks at the shoulder joint (A); at the bottom of the rib cage, where the elbow would be (B); and at the pubic bone or crotch—the halfway point of the body—where the wrist would fall (C). Then measure the distance between A and B and between B and C, and simply apply those measurements to the arms in whatever position you choose to pose them. The only exception to this would be when foreshortening is used.

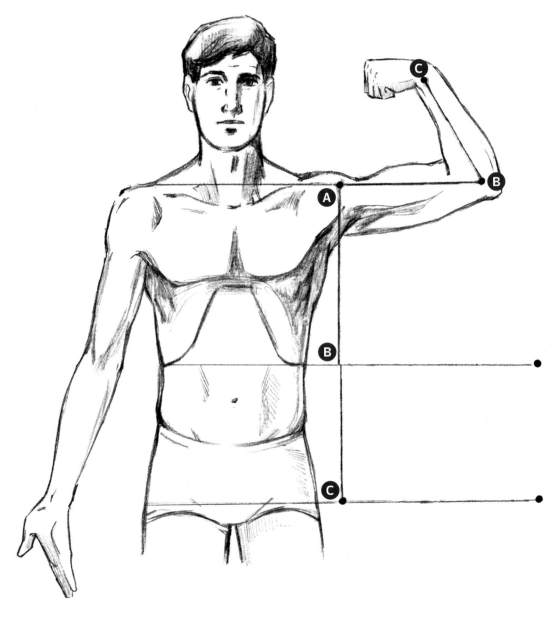

Ⓐ, Ⓑ The length of A to B is the same in any position (except when foreshortening is used).

Ⓑ, Ⓒ The length of B to C is the same in any position (except when foreshortening is used).

The Wrist

Where the wrist falls in relation to the body determines the overall length of the arms. Hands are trickier to use as a measuring point because the hand can bend back and forth, and so can the fingers, which make the length of the hand variable. Not so if your measuring point is the wrist.

The wrist falls at the level of the crotch. Since the crotch is the midway point of the body, we can say that the wrist, when relaxed and at the side, appears at the halfway point of the figure. Technically, the wrist falls ever so slightly below the crotch, but the difference is inconsequential. Therefore, the wrist/crotch mark has been adopted as the standard.

Further, when the hand is open and the arm is relaxed at the side, the fingertips reach halfway down the upper leg.

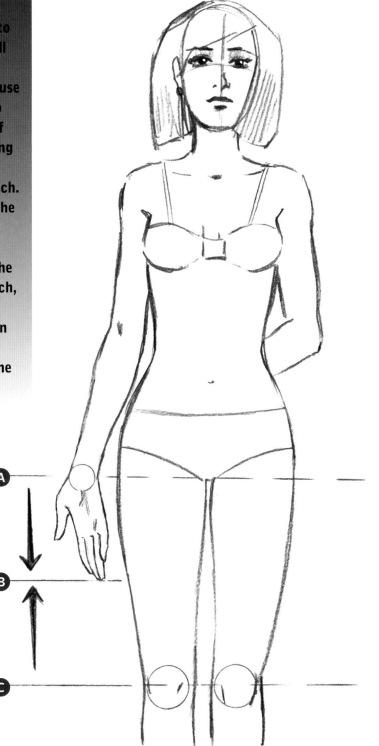

A Level of crotch (or pubic bone)

B Midway point of thigh

C Knees

The Effect of Motion on Wrist Placement

Some artists are tempted to throw up their hands when the body moves, because it seems to throw the proportions out of whack. Well, not exactly. In fact, it creates new, but very predictable, proportions that you can easily follow: When the arm is bent, the elbow is higher than the bottom of the rib cage. (Also note the rising shoulder, which pulls the arm higher.) When the body favors one side by bending downward, not only does the elbow dip below the bottom of the rib cage but the wrist dips below the level of the crotch.

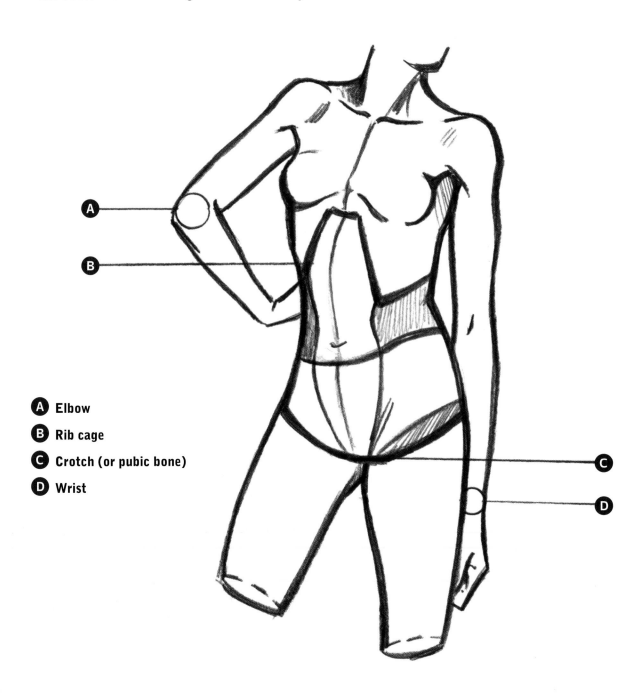

A Elbow

B Rib cage

C Crotch (or pubic bone)

D Wrist

The Legs

Measuring the leg from the *great trochanter* (the large joints on the outer hip that give the hips their width) feels natural for those with a working knowledge of anatomy. But for those wanting a simpler approach, the crotch serves as a better place from which to measure, and it's just as accurate.

If you include the foot in the measurement of the leg, you see that the thigh is the shorter section, and the calf with the foot included is the longer section. (You're dividing the leg at the midpoint of the knee.)

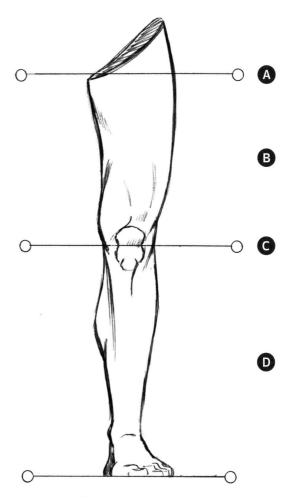

A Crotch

B Thigh is shorter

C Midpoint (knee)

D Lower leg and foot are longer

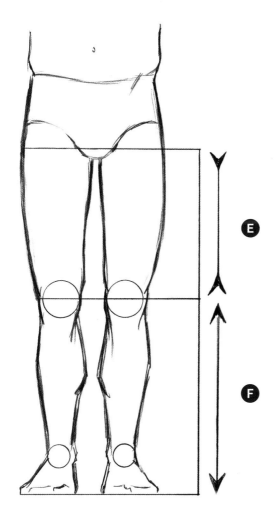

E Shorter

F Longer

KEY POINT

The upper leg is shorter than the lower leg when you include the foot.

97

The Calf

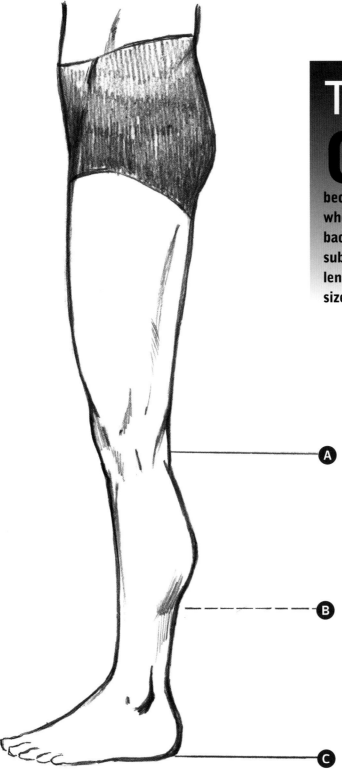

One of the most prominent muscles is the calf muscle, or *gastrocnemius.* That's because it appears to bulge even when it's not flexed. It begins at the back of the knee and peaks to a substantial size. Midway down its length, the calf begins to lose its size and then tapers to the foot.

A

B

C

KEY POINT

The prominent muscle of the calf takes up 1/2 of the length of the lower leg.

Ⓐ Top of lower leg

Ⓑ Midpoint—calf muscle deflates

Ⓒ Bottom of lower leg

Comparing the Arm to the Lower Leg

If you compare the overall length of the lower leg and foot to the upper and lower arm, you get a feel for their true length.

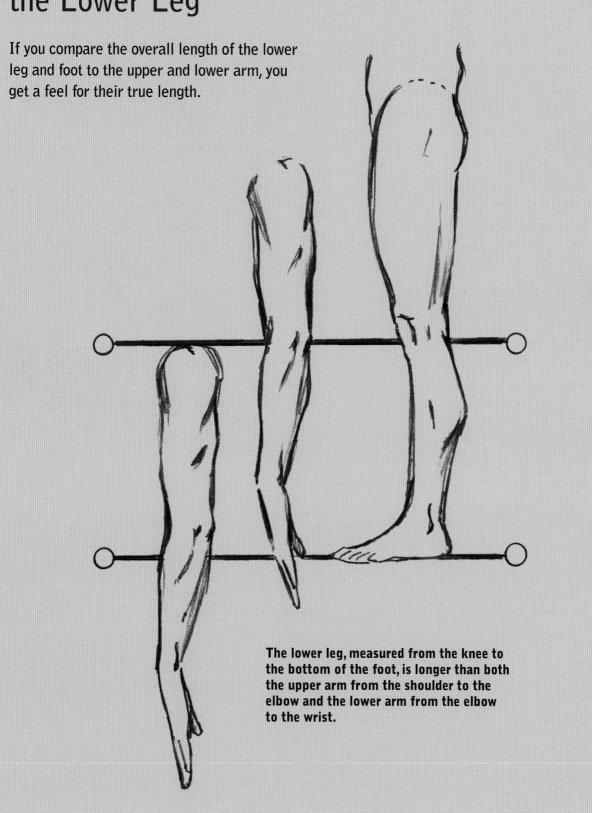

The lower leg, measured from the knee to the bottom of the foot, is longer than both the upper arm from the shoulder to the elbow and the lower arm from the elbow to the wrist.

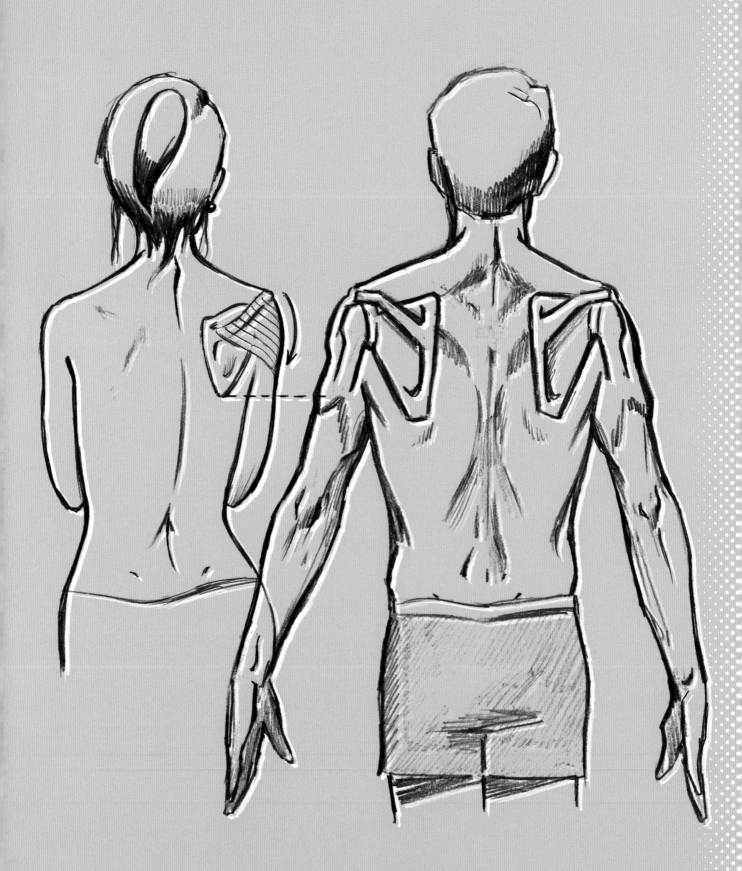

The Back

For many artists, the back is somewhat of a mystery and, therefore, gets short shrift in their drawings: just add a couple of shoulder blades and you're done. That's not a bad start, but if you only indicate one feature to define such a massive area, you're neglecting several pretty big pieces of the puzzle.

The four muscles that are either part of the shoulder blade, or partially overlap it, have obscure anatomical names, like the *rhomboideus major* and the *teres major*. Regardless, because the backs of most nonathletes are somewhat underdeveloped, it's almost impossible to identify, from the skin level, any of the muscles on the shoulder blades. This leaves us the proportions to work with, which are easily located on any back.

The Shoulder Blades

Outside of the spine, the shoulder blades are the most prominent feature of the back. Therefore, it's important to get the dimensions and placement correct. Let's find out how to make it work. The proportions of the shoulder blade (*scapula*) are more forgiving than many other body proportions. This is because there are fewer landmarks on the back with which to compare the shoulder blade's size and position. A common measuring tool that's easy to use is the hand. It works well because we have an intuitive sense of its size.

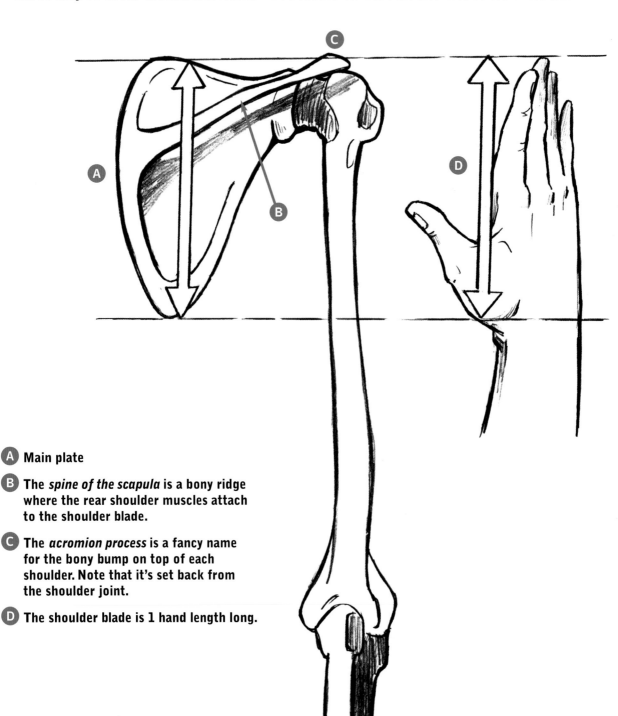

A Main plate

B The *spine of the scapula* is a bony ridge where the rear shoulder muscles attach to the shoulder blade.

C The *acromion process* is a fancy name for the bony bump on top of each shoulder. Note that it's set back from the shoulder joint.

D The shoulder blade is 1 hand length long.

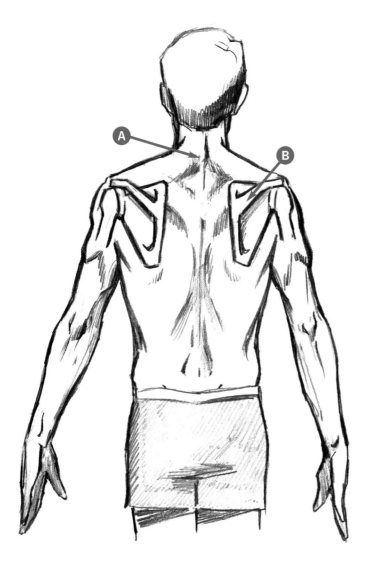

A Seventh vertebra of the neck

B The shoulder blade always appears *below* the seventh vertebra at the base of the neck.

In application, we see that the top of the shoulder blade, which shows through to the surface, is really the bony protuberance called the *spine of the scapula.*

The Height of the Shoulder Blades, Side View

The side view gives us a good idea of how high up on the body the shoulder blades are drawn. The level of the shoulder blades lies between the collarbone and the sternum.

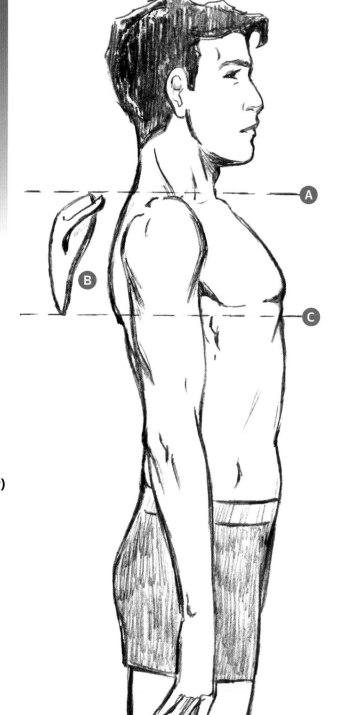

A Collarbone

B Shoulder blade (*scapula*)

C Sternum

The Length of the Shoulder Muscles, Rear View

The shoulder blades are lower, down the back, than the shoulder muscles. Fortunately for us, shoulder blades are usually visible, and often substantially articulated, on the back. This makes measuring them easy. Look for an indentation at the bottom of the shoulder muscle. The shoulder blade appears a notch below that.

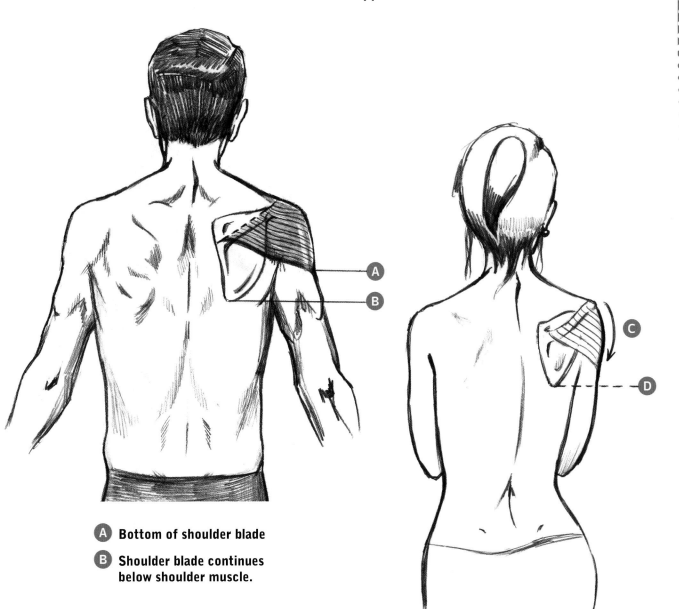

A Bottom of shoulder blade

B Shoulder blade continues below shoulder muscle.

C The shoulder muscle indents at the bottom, which is our measuring point.

D The shoulder blade comes to a point at the bottom, which is often visible through the skin's surface.

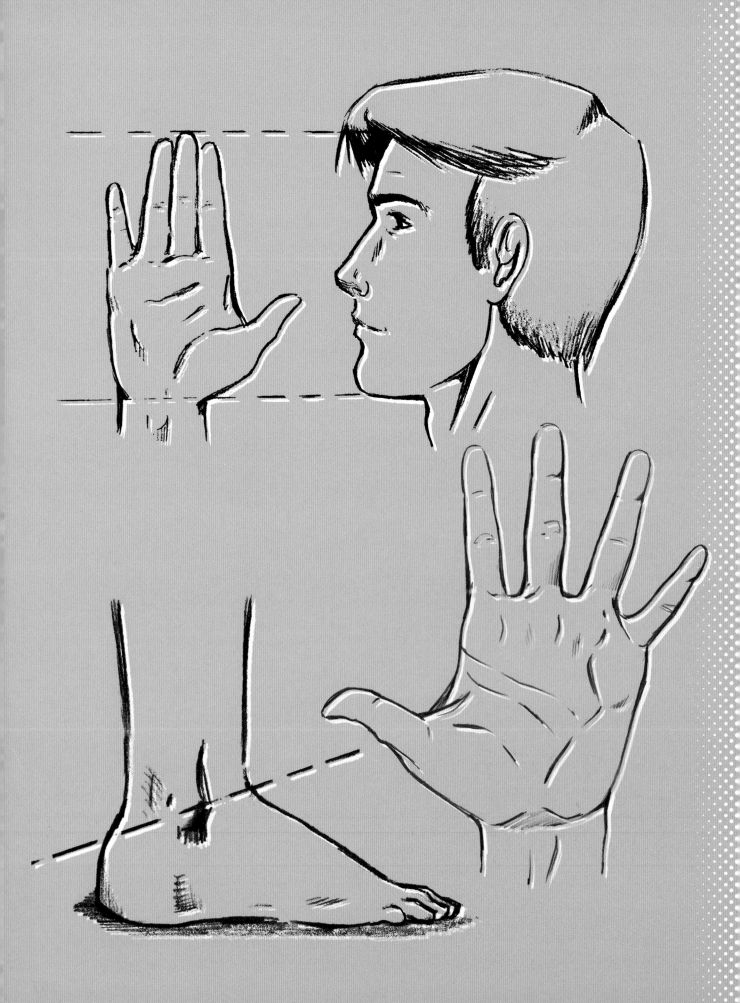

The Hands and Feet

Perhaps you've always found hands and feet easy to draw. You'd be the first one. For the rest of the human population, it's challenging. Poorly constructed hands and feet can mar the look of an otherwise fine drawing. Fortunately, there are a number of useful proportions for drawing the hands and feet. This information can replace trial and error, which has caused eraser smudges to ruin many a drawing.

The Hand: Overall Size

From the tip of the middle finger to the bottom of the wrist, the hand is approximately the same length as the face (measured from the hairline to the bottom of the chin). Don't some people have longer hands and fingers while others have shorter ones? Absolutely. But this is the established average. As such, it makes a reliable starting point, whether you're drawing a person with long fingers or short ones.

The fingers themselves are placed somewhat off-center on the hand. If they were divided evenly, two fingers would be left of center and two fingers right of center. But the mass of the thumb and the thumb heel of the palm act as a counterbalance to the fingers. To find the true center of the hand, draw a line from the tip of the middle finger to the center of the base of the palm.

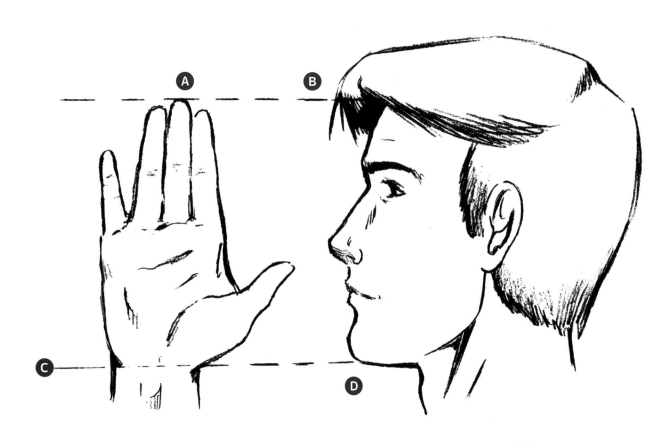

A Tip of tallest finger **C** Base of palm

B Hairline **D** Bottom of chin

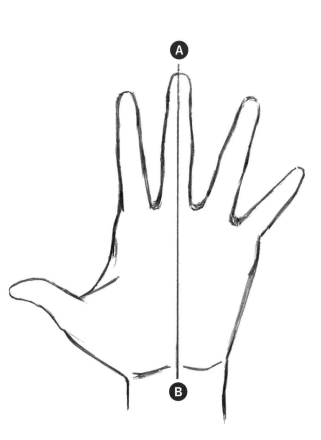

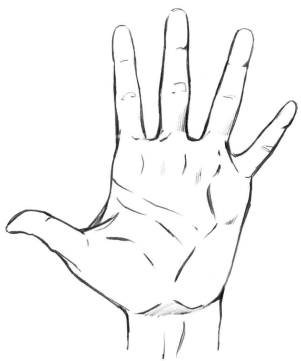

A Middle finger is center of hand

B Base of palm

Diagram of Digit Segments

The row of knuckles closest to the wrist is the halfway point of the hand lengthwise.

A Base of hand

B Ridge of knuckles—halfway point

C Middle fingertip

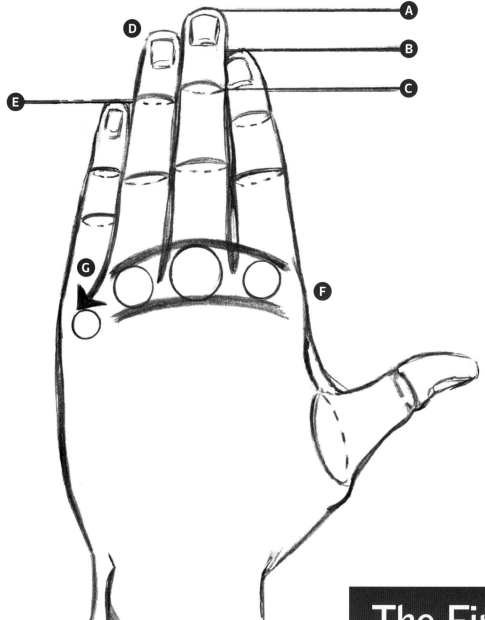

A Tip of middle finger

B The tip of the index finger is halfway up the first third of the middle finger.

C First joint of middle finger

D A close look at the ring finger reveals that it is most often, but not always, a touch higher than the index finger.

E The tip of the little finger appears at the first joint of the ring finger.

F The knuckles are drawn on an arching guideline.

G The skin tugs in this direction, toward the outside of the palm.

The Fingers

You can see that the middle finger is the longest, followed by the ring finger, the index finger, and the little finger. Therefore, the challenge lies in finding their relative sizes to one another. How much taller or shorter one finger is than another is not always so clear. The easiest way to determine this is to use the joints as measuring points. The index finger travels halfway up the first joint of the middle finger, for example. The diagram calls out more benchmarks.

The Length of the Thumb and Other Details

The thumb is short, and when placed side by side with the index finger, you see that the tip of the thumb rises just slightly above the bottom knuckle of the index finger. In addition, the tip of the pinkie aligns approximately with the highest joint of the ring finger.

When the fingers are side by side, you can see their relative lengths.

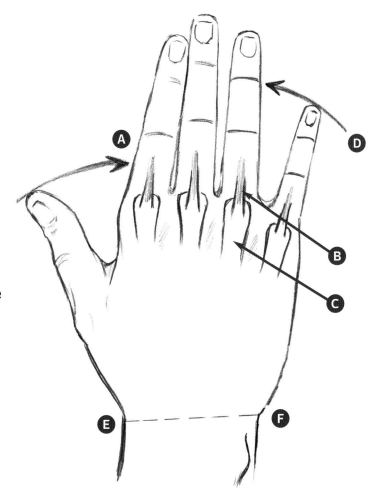

A The thumb rises past the knuckle at the base of the index finger.

B Tendon

C Metacarpal bone

D Tip of pinkie

E Slightly lower

F Slightly higher

The Foot

Drawing the foot at the correct size is as simple as using the head as a measurement. They're the same size. This illustration explains the concept. So, in practical use you would note, for example, that the length of the head is 2 inches long, so you would then sketch a foot that's also 2 inches long.

KEY POINT
The foot and head are of equal length.

Equivalent length

The Heel

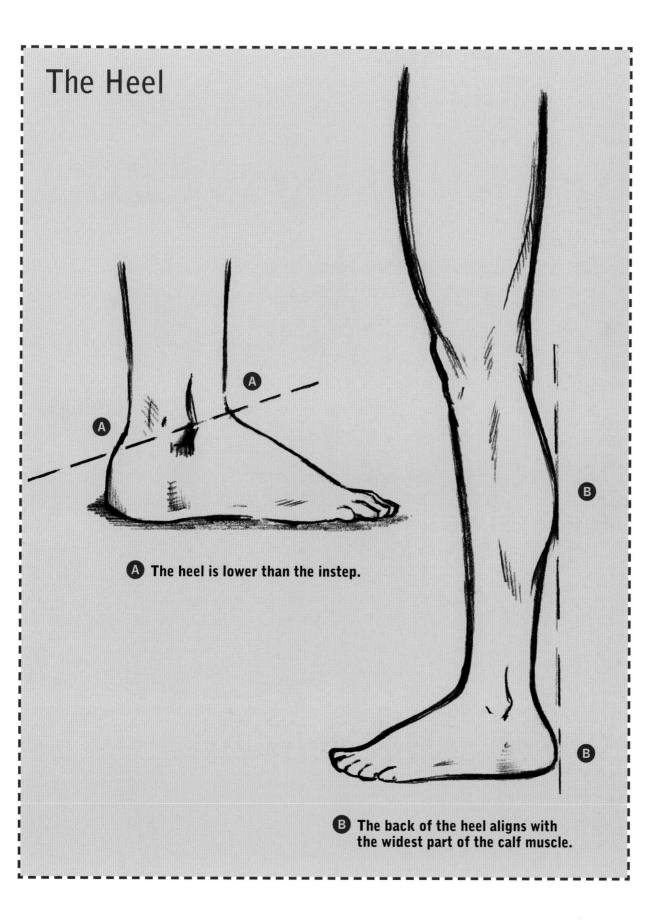

A The heel is lower than the instep.

B The back of the heel aligns with the widest part of the calf muscle.

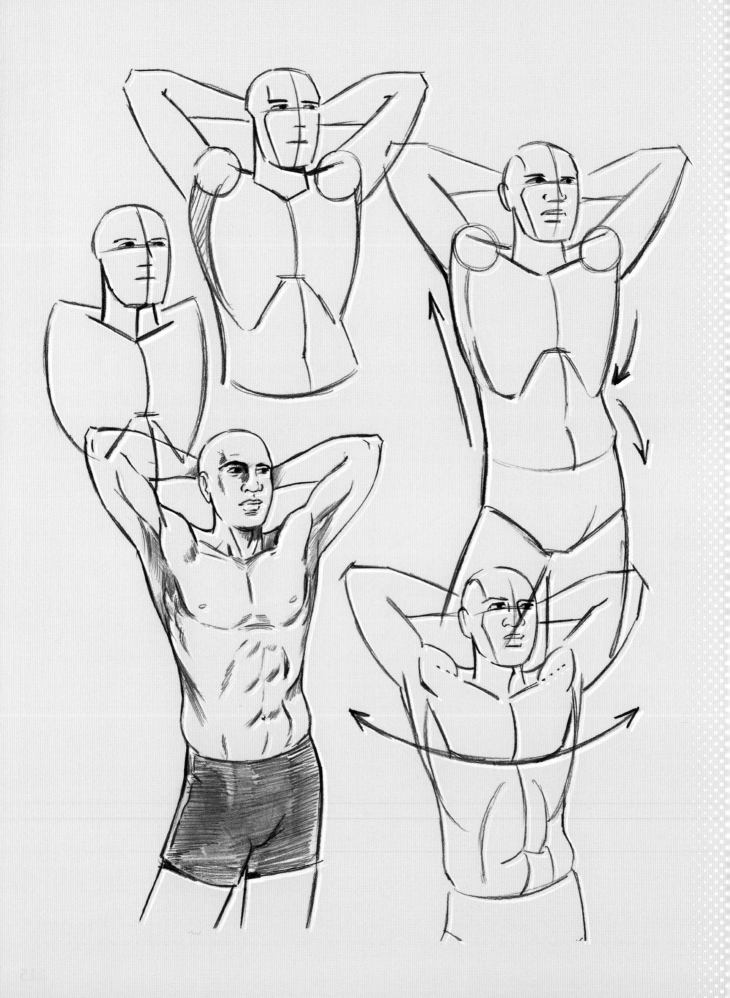

Step-by-Step Tutorials: The Figure

This chapter presents a number of step-by-step examples from a variety of angles. By following the steps and hints, you'll see how a figure is constructed with the proper proportions built into the foundation.

You'll also have the option of adjusting each pose to add your own touch. You might raise or lower an arm. You could shift the weight from one leg to the other. You could turn the head in a different direction. You now have the resources to do it, while maintaining the proper proportions.

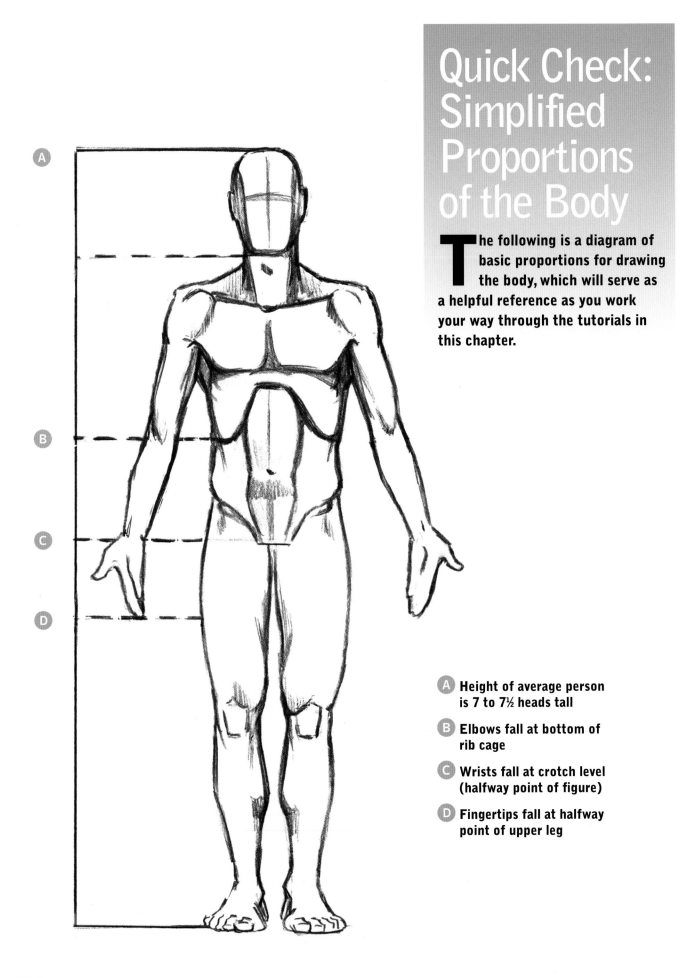

Quick Check: Simplified Proportions of the Body

The following is a diagram of basic proportions for drawing the body, which will serve as a helpful reference as you work your way through the tutorials in this chapter.

A Height of average person is 7 to 7½ heads tall

B Elbows fall at bottom of rib cage

C Wrists fall at crotch level (halfway point of figure)

D Fingertips fall at halfway point of upper leg

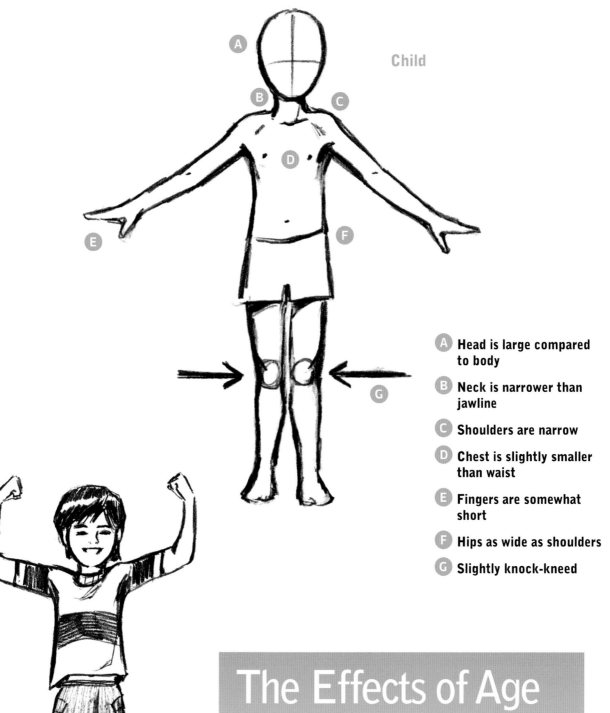

Child

A Head is large compared to body

B Neck is narrower than jawline

C Shoulders are narrow

D Chest is slightly smaller than waist

E Fingers are somewhat short

F Hips as wide as shoulders

G Slightly knock-kneed

The Effects of Age on the Body

In "Features of the Face," we look at the different effects that age has on the face as it specifically relates to eye placement. Naturally, age affects the body as well. Children are fewer heads tall than adults. In plainer language, that means that their heads look bigger in relation to their bodies. And the bodies of middle-aged and older adults show the effects of gravity, among other changes listed on the following page.

117

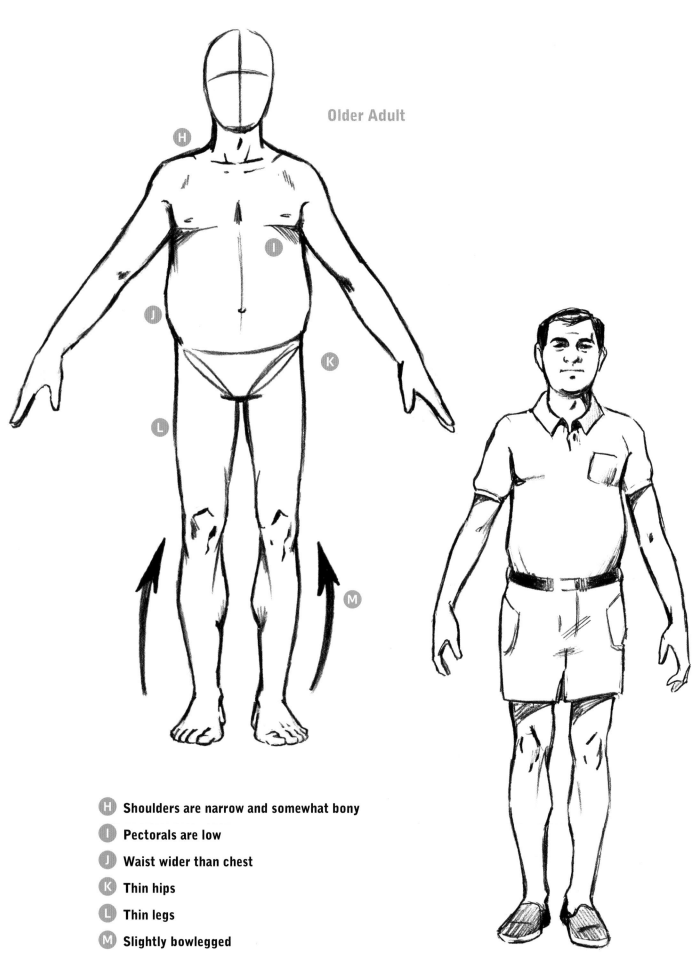

Older Adult

H Shoulders are narrow and somewhat bony

I Pectorals are low

J Waist wider than chest

K Thin hips

L Thin legs

M Slightly bowlegged

The Torso, Hands on Hips

Begin by drawing basic shapes, which you connect together to approximate the human figure. Once those are in place, you can get down to work, sculpting out the various contours and details step-by-step.

Drawing tradition dictates that symmetrical poses are to be avoided, because they are uninteresting. But there are some problems with this "rule." People do sometimes pose or stand symmetrically. But are all symmetrical poses boring? What about a heroic pose? We could add a tilt to the shoulders in a heroic pose to create asymmetry, but then it wouldn't appear as sturdy and self-assured.

The neck and rib cage overlap.

The eye line curves down to make it appear that we're looking slightly up at this figure.

The elbows are bent and, therefore, are slightly above the level of the bottom of the rib cage.

The Basic Sections of the Upper Body

Head and neck
Chest and torso
Hip region and
 upper thigh

Proportion Hint

The body is 3 heads wide at the shoulders.

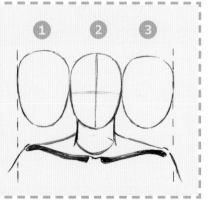

119

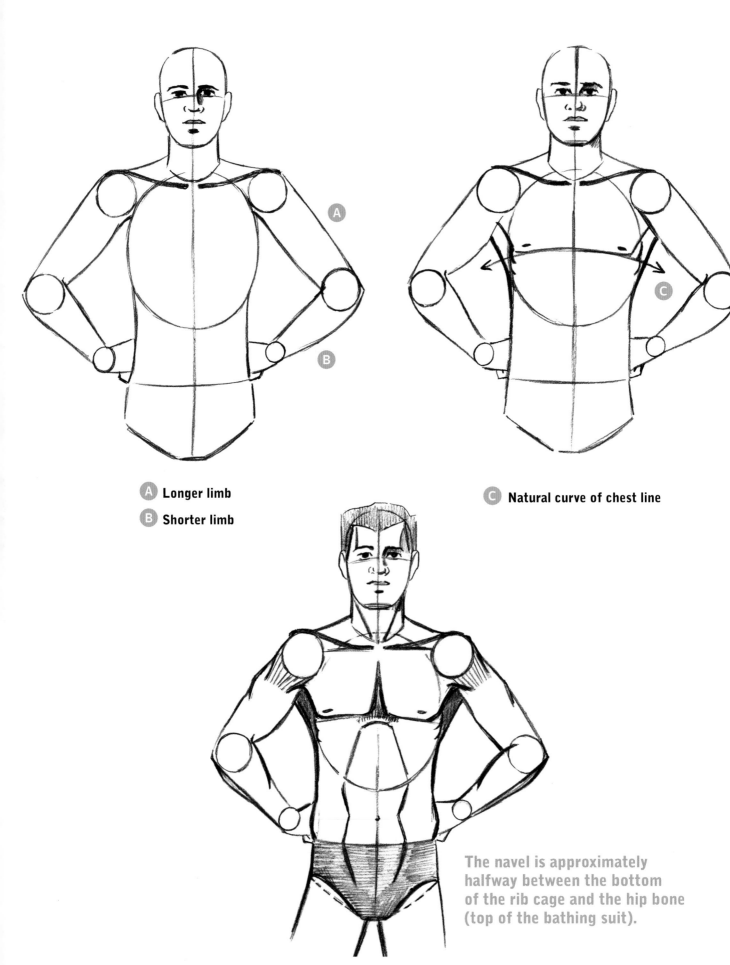

A **Longer limb**

B **Shorter limb**

C **Natural curve of chest line**

The navel is approximately halfway between the bottom of the rib cage and the hip bone (top of the bathing suit).

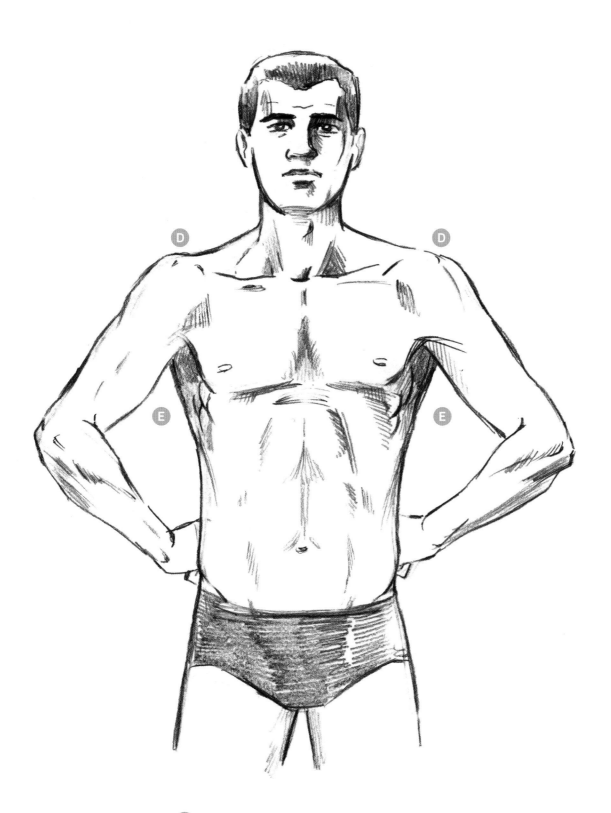

D The shoulder hides part of the collarbone, but the collarbone continues and reappears at the end.

E The back muscles (*latissimus dorsi*) add width to the sides of the torso.

The Torso, Arms Up

With the arms raised, the torso becomes the focus of the pose; therefore, you'll want to define its interior to add interest. Before you knew the proportions of the body, it may not have occurred to you to indicate the placement of the rib cage, clavicle (collarbone), sternum, abdominal wall, and more when drawing the torso. But now you have new tools you can use to create drawings with more authority.

Many aspects of the torso can be suggested by subtle shading and slight contours. When your proportions are correct, you don't have to be heavy-handed.

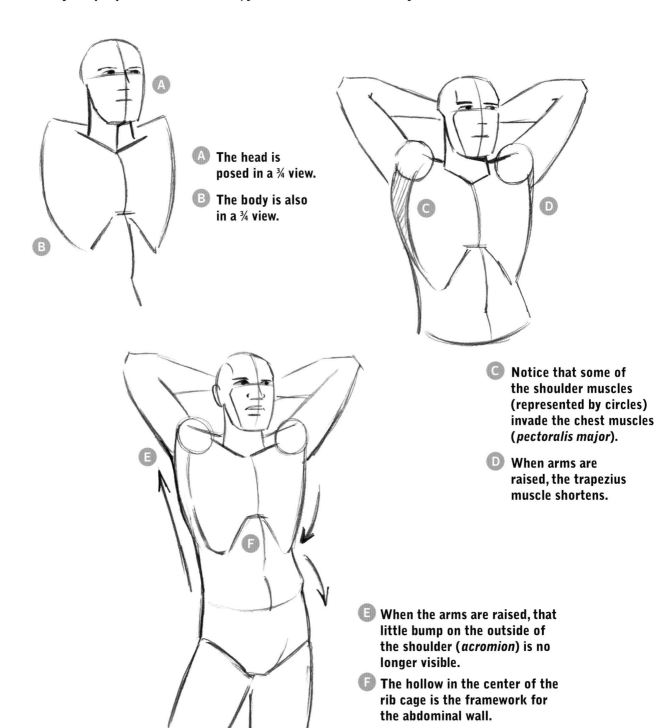

A The head is posed in a ¾ view.

B The body is also in a ¾ view.

C Notice that some of the shoulder muscles (represented by circles) invade the chest muscles (*pectoralis major*).

D When arms are raised, the trapezius muscle shortens.

E When the arms are raised, that little bump on the outside of the shoulder (*acromion*) is no longer visible.

F The hollow in the center of the rib cage is the framework for the abdominal wall.

122

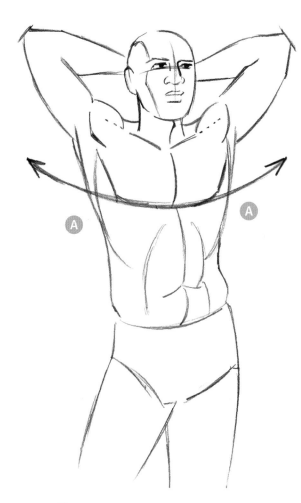

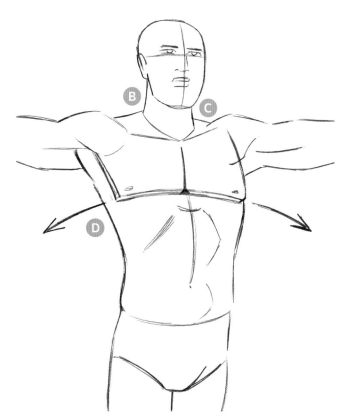

A When the arms are raised, the line of the chest muscles curves upward.

B The near plane of the face, which is nearer to the viewer, appears larger from this angle.

C The far plane of the face, which is farther from the viewer, appears smaller from this angle.

D When the arms are straight out or down, the line of the chest muscles curves downward.

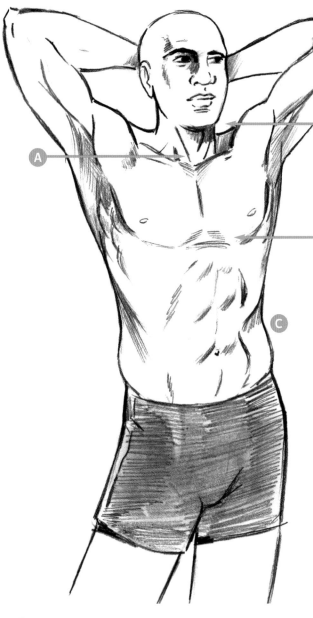

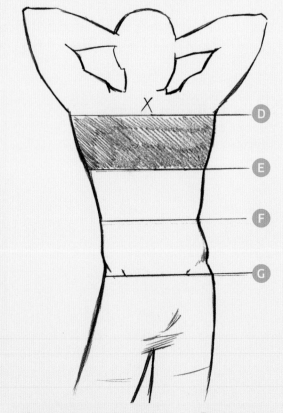

Proportion Hint

The chest occupies about ⅓ of the torso. Here are a few of the more common torso landmarks, which you can use to determine the correct proportions of a body part or a section.

A The major muscles of the front of the neck (*sternocleidomastoideus*) converge at the pit of the neck.

B As we learned earlier, note that there is 1 head length between the chin and the sternum.

C A subtle indentation is all that's needed to indicate the bottom of the rib cage.

D Pit of the neck (shown at the X)

E Sternum

F Bottom of rib cage

G Front hip bones

The Torso, ¾ Rear View

This ¾ view is a back view and is made more dramatic by twisting the torso slightly toward the viewer. This twisting action, which reflects the line of the spine, creates a nice, visual flow in the drawing.

A pose that appears challenging is best captured by first concentrating on the basic building blocks, which in this case means blocking out the head and torso.

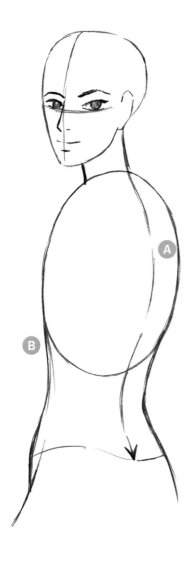

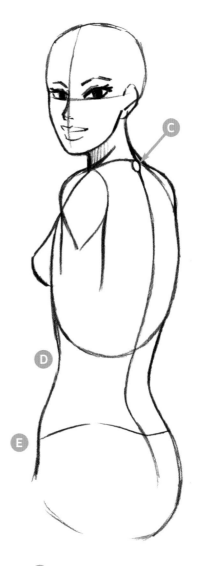

A Flow of spine

B Rib cage

C Seventh vertebra

D Indentation hints at bottom of rib cage

E Top of pelvic bone

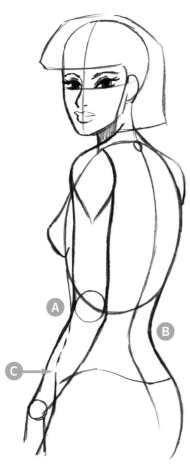

A A sliver of the rib cage appears in front of the arm, which also adds depth to the image.

B The spine flows in and out, following the contours of the rib cage, the midsection, and then the pelvis.

C The knob of the hip bone in front (*the crest of the ilium*)

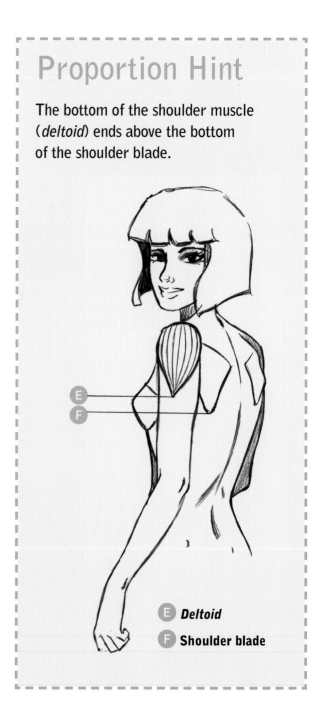

Proportion Hint

The bottom of the shoulder muscle (*deltoid*) ends above the bottom of the shoulder blade.

E *Deltoid*

F Shoulder blade

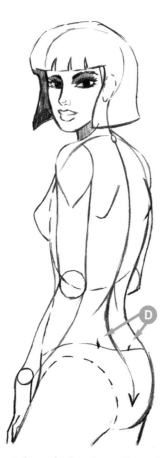

D The *iliac tuberocity* is where the pelvic bone makes two small indentations at the bottom of the back.

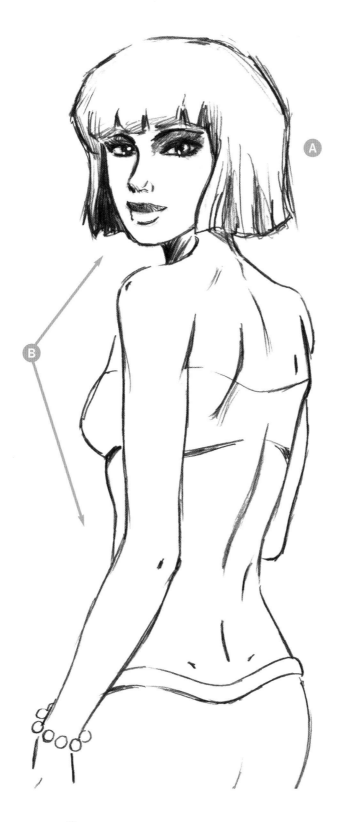

A In the ¾ view, the back of the head is still a sizeable area.

B The head is in a ¾ front view, while the body is in a ¾ rear view, which creates a nice contrast in the pose.

Standing Pose, Front View

Here's a problem we've all encountered at one time or another. You begin a drawing only to find that, once you're halfway into it, you're going to run out of room on the page.

KEY POINT

This pose has increased interest because various sections of the body are facing in slightly different directions.

Head: left
Torso: right
Hips and legs: front

The solution is a simple trick I learned in art school: Begin by drawing a vertical *height line*, which represents the entire length of the figure. It doesn't have to be a flowing line or reflect the contours of the body in any way. It's strictly a line that shows the length of the figure. Make sure that there's room on the page above the top of the guideline (the point that would be the top of the head) and below the bottom of the guideline (the point that would be the feet). Then proceed to draw the figure along this line. You can't go wrong.

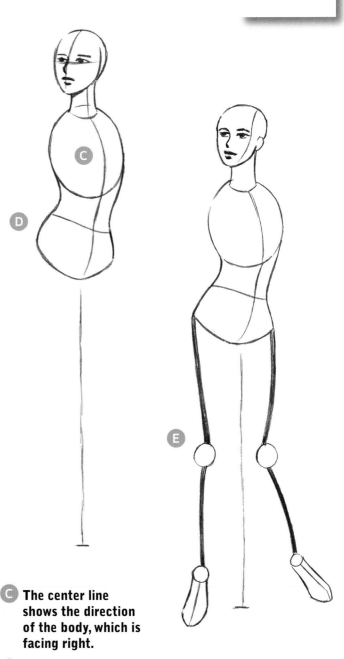

Ⓐ Indicate the top and bottom of the guideline.

Ⓑ Height line

Ⓒ The center line shows the direction of the body, which is facing right.

Ⓓ Note the tilt of the hips; the left side is up.

Ⓔ The left leg is the straighter of the two, which usually indicates that it's the one bearing the weight.

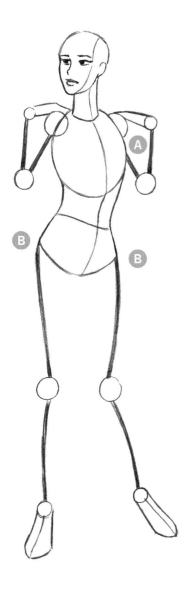

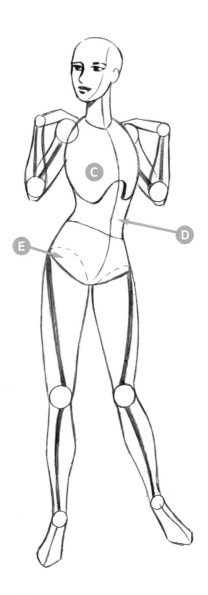

Construction completed
and ready for finishing.

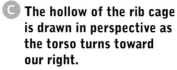

C The hollow of the rib cage
is drawn in perspective as
the torso turns toward
our right.

D The center line shows
the direction the body
is facing.

E The muscles of the thigh
originate deep inside the
hip area.

A While the near arm is clearly
visible, the far arm is
overlapped to some degree
by the torso, creating the
illusion of depth.

B Earlier in the book, you
learned that the thigh joint
represents the widest spot
on the body.

Working from the last step in the construction, blend the elements so that they go together smoothly to avoid the look of a figure assembled from a collection of parts.

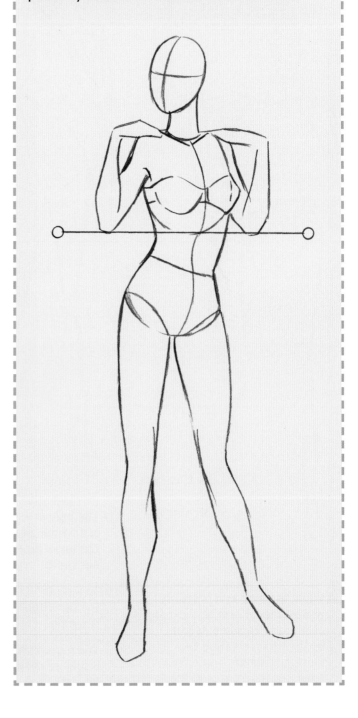

Proportion Hint

The elbow aligns with the bottom of the rib cage when the upper arms are in the "down" position, whether or not the forearms are.

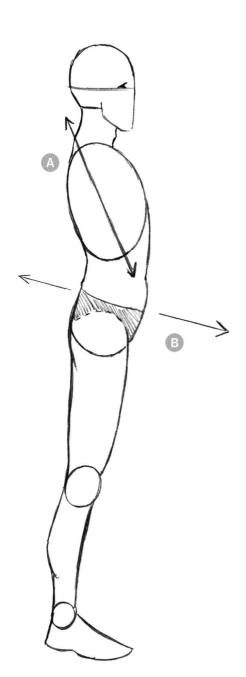

Standing Pose, Side View

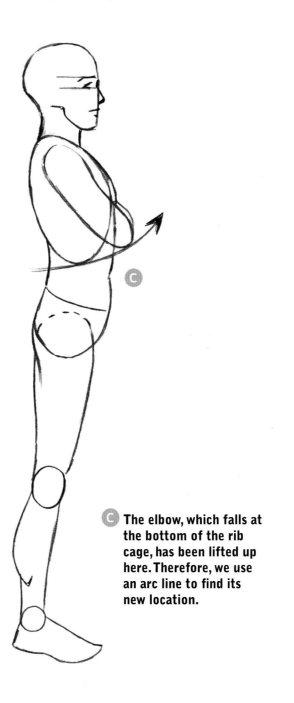

Many beginners draw a figure in profile without much definition because they're unsure of themselves. With the correct proportions, however, you can locate and articulate various body parts at any angle. Among the most important elements of a good side-view pose are the tilts of the rib cage and hips.

A Rib cage tilts back

B Hips tilt forward

C The elbow, which falls at the bottom of the rib cage, has been lifted up here. Therefore, we use an arc line to find its new location.

Step-by-Step Tutorials: The Figure

131

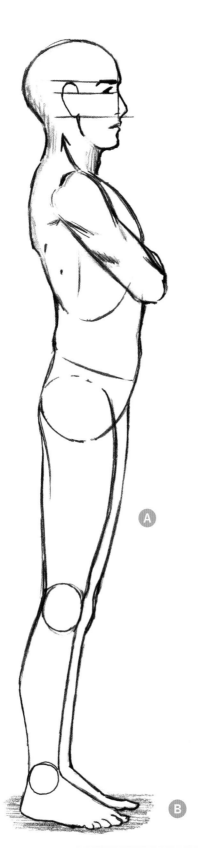

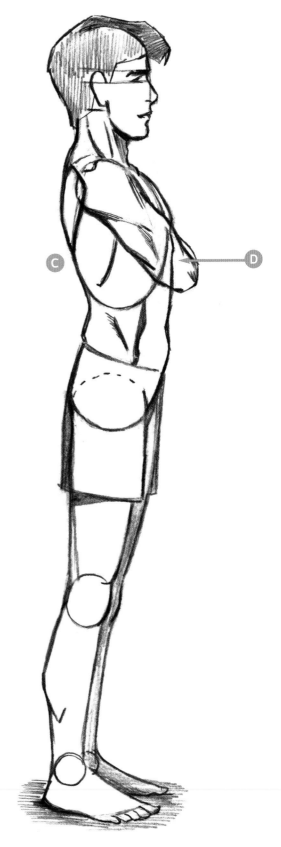

A The far leg is overlapped by the front leg.

B The feet are on two slightly different levels: The near foot appears lower than the far foot.

C Shoulder blade aligns with bottom of sternum

D Bottom of sternum

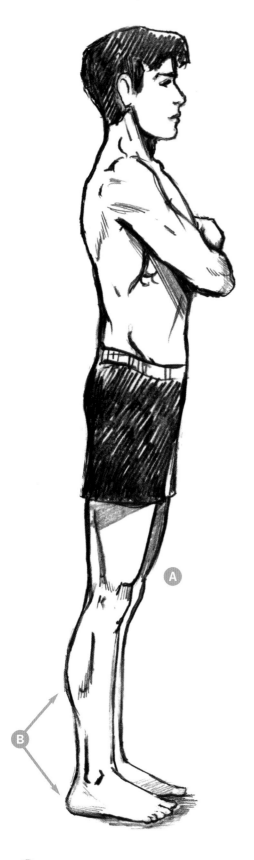

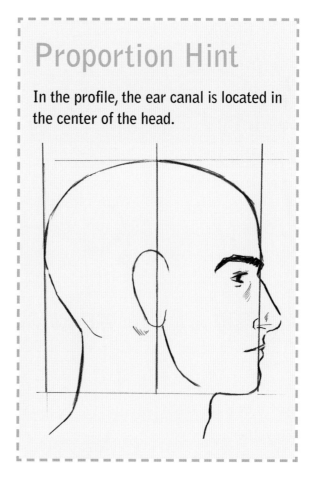

Proportion Hint

In the profile, the ear canal is located in the center of the head.

(A) The middle thigh muscle (*rectus femoris*) slightly overhangs the knee when the knee is in the locked position.

(B) The calf and heel extend back equal lengths.

Bending Pose, Side View

It may seem impossible to double-check the proportions when the figure is bending. Here's the solution: Because each body part retains its own proportions, you can still measure them against one another.

For example, you know that the crotch, or pubic bone, is the halfway point on the body. This important proportion keeps the figure looking right. So, how do you measure where the halfway point is when the torso and legs go in different directions? Simple. Measure the top half of the figure from the head to the halfway point (measurement A), and then measure the bottom half of the figure from the halfway point to the heel (measurement B). When the length of A equals the length of B, you've got it.

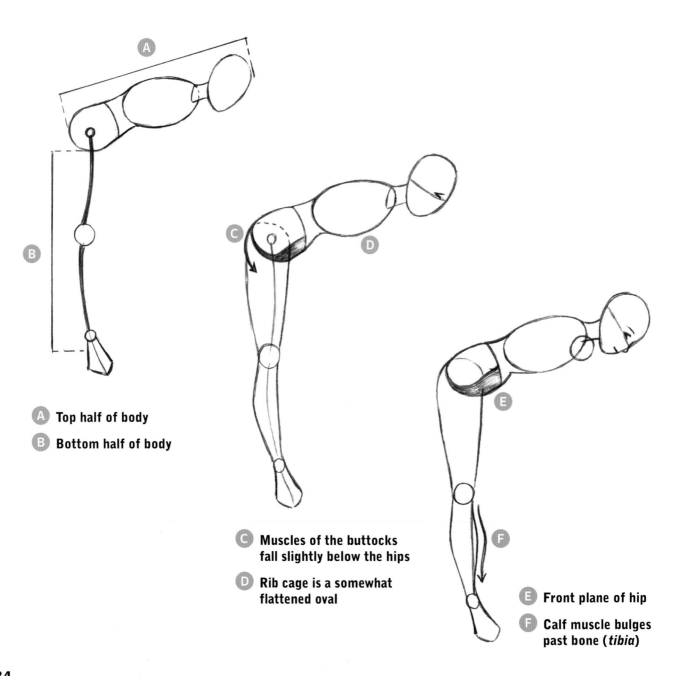

Ⓐ Top half of body

Ⓑ Bottom half of body

Ⓒ Muscles of the buttocks fall slightly below the hips

Ⓓ Rib cage is a somewhat flattened oval

Ⓔ Front plane of hip

Ⓕ Calf muscle bulges past bone (*tibia*)

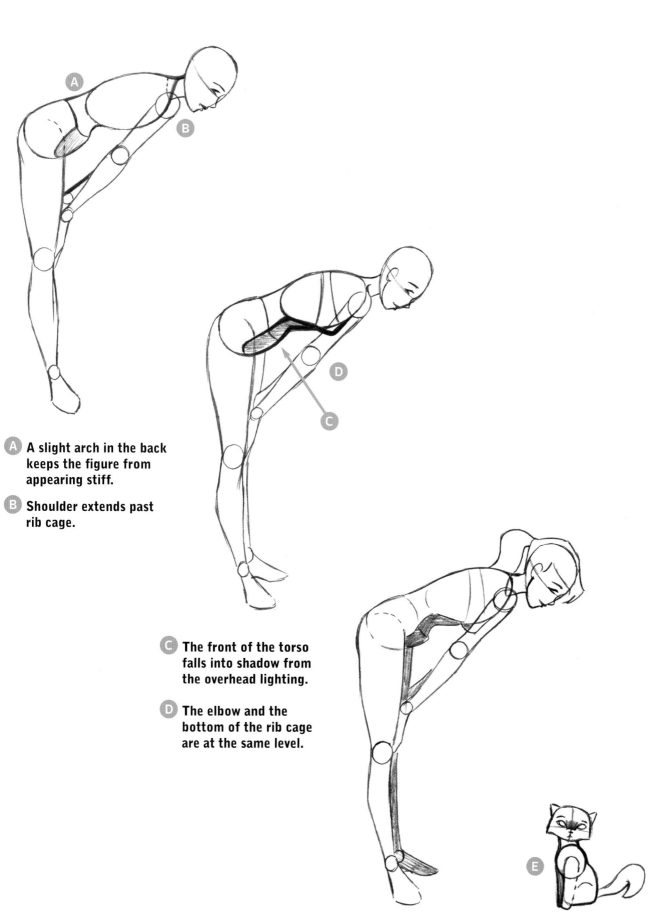

A A slight arch in the back keeps the figure from appearing stiff.

B Shoulder extends past rib cage.

C The front of the torso falls into shadow from the overhead lighting.

D The elbow and the bottom of the rib cage are at the same level.

E Let's have a little fun by introducing a friend—with its own set of proportions!

135

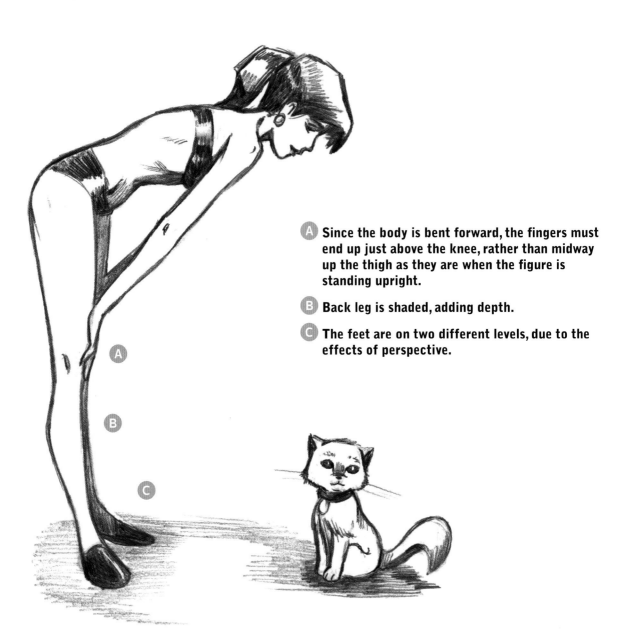

A Since the body is bent forward, the fingers must end up just above the knee, rather than midway up the thigh as they are when the figure is standing upright.

B Back leg is shaded, adding depth.

C The feet are on two different levels, due to the effects of perspective.

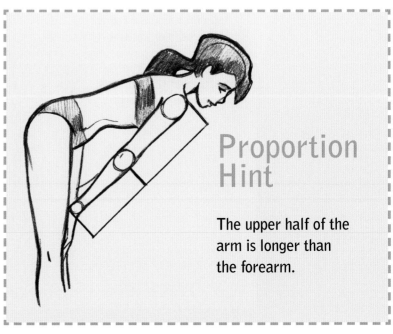

Proportion Hint

The upper half of the arm is longer than the forearm.

Bending Pose: Cheating a Side View

This side view looks somewhat more three-dimensional than the previous one. That's because it makes use of a technique called *cheating*. This is a tried-and-true art technique and there's no moral judgment on it. You don't get a bad grade for using a side view cheat in art school. ("Cheating" simply means adding a slight rotation to the side view to suggest depth.) It's a good approach, which you have as an option.

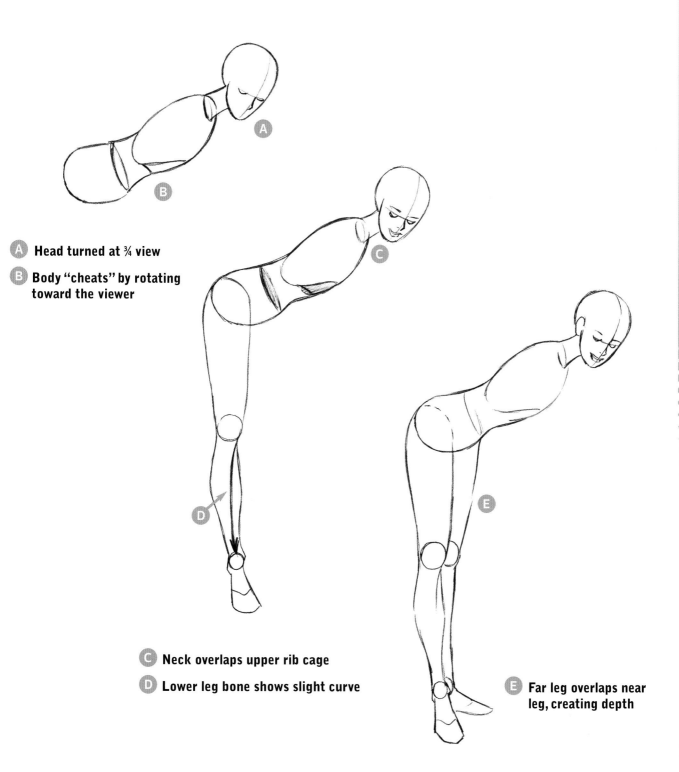

A Head turned at ¾ view

B Body "cheats" by rotating toward the viewer

C Neck overlaps upper rib cage

D Lower leg bone shows slight curve

E Far leg overlaps near leg, creating depth

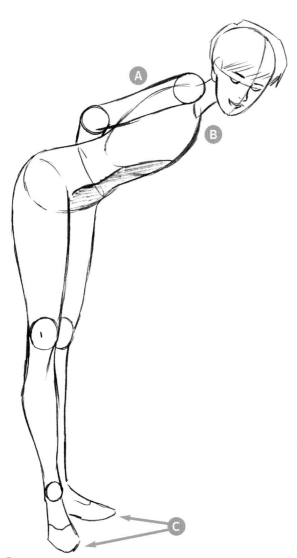

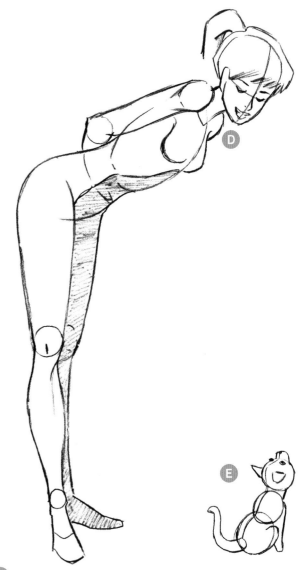

(A) **Arm overlaps torso (a sign of depth)**

(B) **Shoulder overlaps neck (a sign of depth)**

(C) **The feet veer off in different directions to help the figure maintain balance.**

(D) **The far shoulder can be seen only because the torso has been rotated toward the viewer.**

(E) **He's back! This time, let's pose him differently.**

Proportion Hint

The elbow and the bottom of the rib cage align. See how natural it looks when you have the proportions correct?

The elbow and the bottom of the rib cage are on the same level.

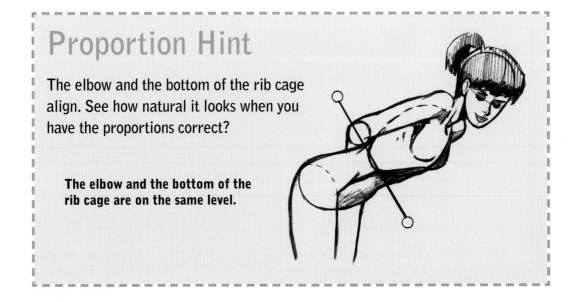

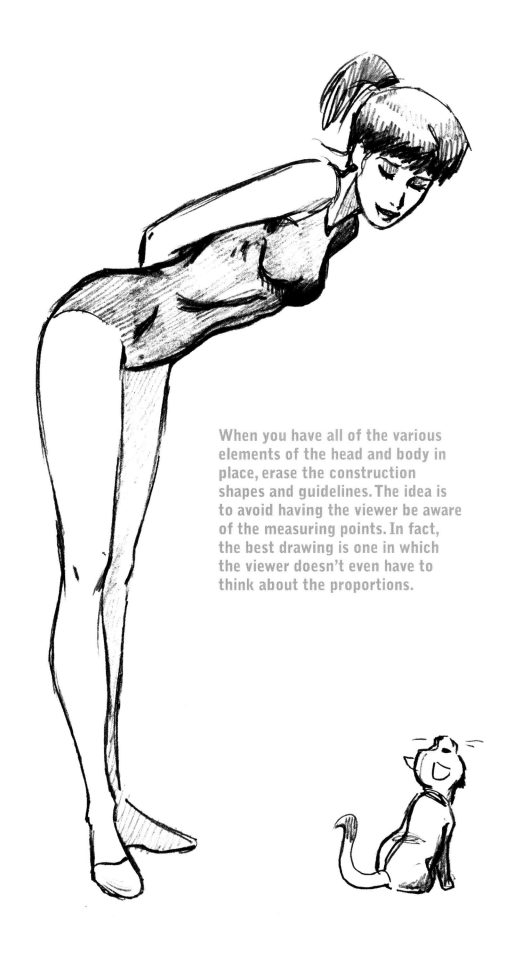

When you have all of the various elements of the head and body in place, erase the construction shapes and guidelines. The idea is to avoid having the viewer be aware of the measuring points. In fact, the best drawing is one in which the viewer doesn't even have to think about the proportions.

Twisting the Torso and Hips, Rear View

Keeping the legs facing in the same direction as the head while turning the shoulders clockwise shows the flexibility of the body as a unit. The line of the spine follows the path created by the twisting motion, which brings a graceful sweep to the figure. But the spine does more than enhance aesthetics; it organizes the image visually for the viewer, defining the perspective middle—the true middle—of the back.

Note the height of the legs: In a regular pose, a straight leg appears higher at the knee than a bent leg; however, in this pose the bent leg is balancing on a foot that's pointed down, which adds length to the bent leg and pushes the knee up slightly, above the knee on the straight leg.

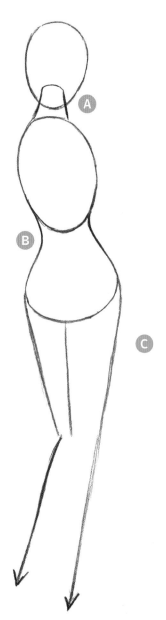
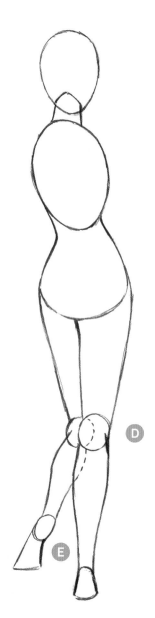
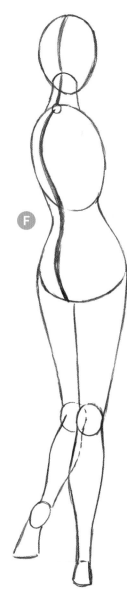

A Neck wedges into back of head

B Sweeping curve of back

C Near leg overlaps part of far leg

D Sketching the knee that's hidden from view ensures that you've got the placement right.

E Accentuate the arch of the foot.

F The spine serves as the perspective middle of the back.

140

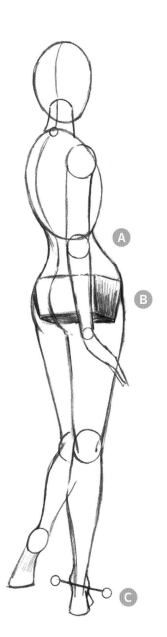

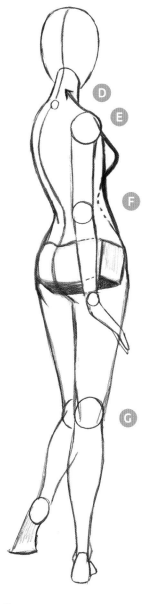

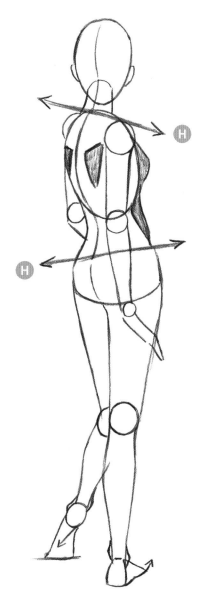

(A) **The elbow falls slightly below the rib cage as a result of the shoulder dipping on that side.**

(B) **The hips have dimension. Think of the pelvis as a shape with four sides.**

(C) **The ankle is high on the inside of the leg and low on the outside.**

(D) **The trapezius muscle overlaps the neck.**

(E) **The near shoulder overlaps the back.**

(F) **The side of the abdominal wall (indicated by the dotted line) overlaps the front of the stomach.**

(G) **The near knee overlaps the far knee.**

(H) **Note the opposing shoulder and hip tilts, which add a dramatic look to the pose.**

141

Proportion Hints

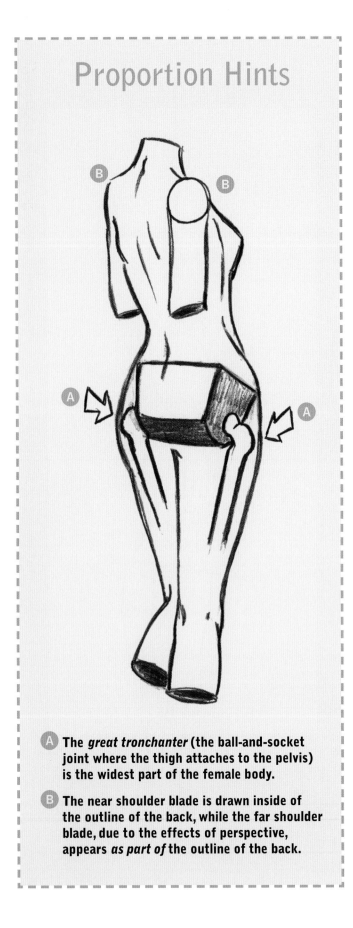

(A) The *great tronchanter* (the ball-and-socket joint where the thigh attaches to the pelvis) is the widest part of the female body.

(B) The near shoulder blade is drawn inside of the outline of the back, while the far shoulder blade, due to the effects of perspective, appears *as part of* the outline of the back.

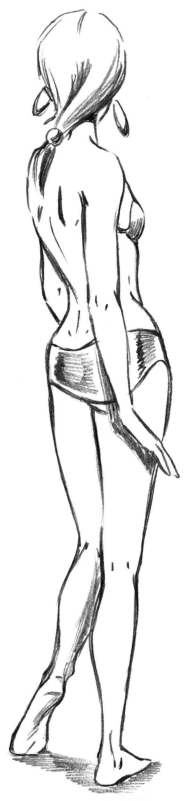

There are numerous proportions that affect this and all other poses. Please don't drive yourself crazy by trying to follow all of them as if you're assembling a piece of machinery. Instead, use this book to familiarize yourself with the basic proportions, and to self-check your work for more detailed proportions.